BraveArt & Teens: A Primer for the Future High School Art Teacher

By: Jodi Patterson

Revised Edition. 2016.

Revised Edition. 2014.

Copyright 2011 by Jodi Patterson.

ISBN ISBN-13: 978-1456493240

ISBN-10: 1456493248

A CreateSpace publication.

Brave

adjective, brav·er, brav·est, noun, verb, braved, brav·ing.

–adjective

1. possessing or exhibiting courage or courageous endurance.

2. making a fine appearance.

3. Archaic . excellent; fine; admirable.

–noun

4. a brave person.

5. a warrior, esp. among North American Indian tribes.

6. Obsolete .

a. a bully.

b. a boast or challenge.

–verb (used with object)

7. to meet or face courageously: to brave misfortunes.

8. to defy; challenge; dare.

9. Obsolete . to make splendid.

–verb (used without object)

10. Obsolete . to boast; brag.

BraveArt - work made and shared by people who are willing to embrace mistakes as part of the process of meaning/message in order to make honest work based on personal BodySelf knowledge.

THANK YOU
Thank you to all the people who have empowered me
so I may empower others.

This book advocates the process of SHARING student work to be the most vital component to meaning-making.

Table of CONTENTS

Frequently Used TERMS

BodySelf – the creative spirit/intuition; access mechanism to the primal.

Contemporary - contemporary means "today." Contemporary art is art made by living artists (or artists who were born of this time). It is often interdisciplinary by nature and aligns with a post-modern construct.

Eternal Contemporary – theory that the extended eras of living are over. Time, fashion, ideas, and cultural needs rapidly change.

In-Form - art emerging from the BodySelf as information. This information informs life via sound, line, color, insight, etc.

Interdisciplinary - means that artists (scholars) work in whatever media best enables them to incarnate their inner vision.

Latent – leadership style that allows for students to feel empowered enough to control their learning due to leader's ability to sit on his/her ego long enough to watch a student take control of his or her learning.

Modern – 1870 to 1980 (debatable). Modern artists include people like Picasso, Motherwell and Manet. Art is categorized as painting, drawing, sculpture, etc. Differentiates between high art and craft. *Postmodernism* sees information as products of the contemporary; avoids master narratives.

Pedagogy – the function or work of a teacher; teaching.

Process – a system that honors the learning that happens between one point and another; often intangible.

Transformation - includes engaging groups and individuals with the means to strive for personal growth, healing, self discovery, empowerment, expanding creative self-expression, identifying life purpose, and setting and achieving goals; is a bi-product of risk and is in a constant state of evolution.

Vision - a focus of energy towards the mental image of a goal.

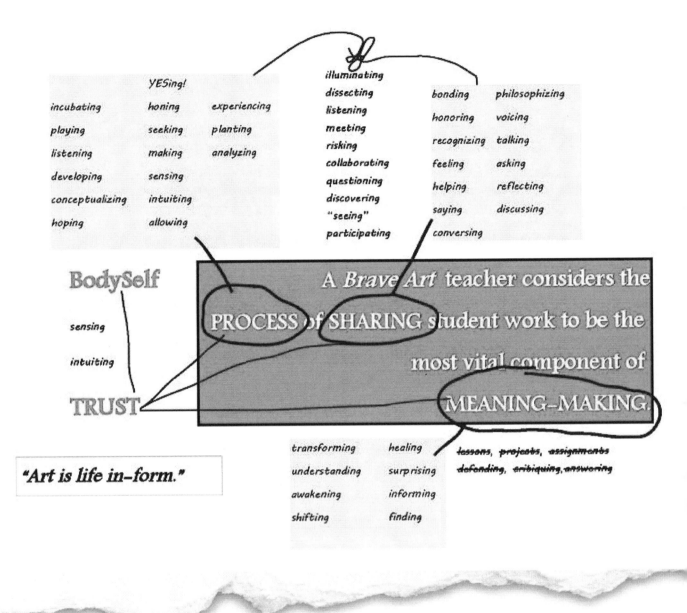

YESing!

incubating honing experiencing

playing seeking planting

listening making analyzing

developing sensing

conceptualizing intuiting

hoping allowing

illuminating
dissecting
listening
meeting
risking
collaborating
questioning
discovering
"seeing"
participating

bonding philosophizing

honoring voicing

recognizing talking

feeling asking

helping reflecting

saying discussing

conversing

BodySelf

sensing

intuiting

TRUST

A *Brave Art* teacher considers the PROCESS of SHARING student work to be the most vital component of MEANING–MAKING.

transforming healing ~~lessons, projects, assignments~~
understanding surprising ~~defending, critiquing, answering~~
awakening informing
shifting finding

"Art is life in-form."

Introduction

Art teachers are brave when they:

- Trust the process of art/meaning-making, rather than make art as an end event.
- Make art and share it with their students.
- Listen to student ideas; allow them to explore unfamiliar territories to the teacher.
- Do not readily hand out answers, but ask students what they think.
- Bring real-world happenings into the classroom for discussion – some of which may counter the teacher's own ideas.
- Label the art room "ours" rather than "mine."
- Tinker with tools and technologies they have no experience with – thus risking (at first) failure - or mediocrity - in front of a class or in private studio.
- Encourage students to ask other students for help, instead of asking the teacher.
- Respect meaning-making over project work.
- Try new teaching methods, without insurance that they will work.
- Sit students in circles, so they can better discuss ideas together.
- Listen, with interest and respect, to stories different from own background.
- Include student input within the grading process.
- Allow students to work with whatever materials they feel best fit their cause.
- Trust the power of art to help students transform into adults.
- Trust students to be brilliant.

Students are brave when they:

- Share dialogue with peers.
- Make marks when he/she otherwise feels incompetent to do so.
- Create for insight, rather than a grade.
- Offer classmates advice, and ask for advice in return.
- Try.
- Look and contemplate art that he/she may initially desire to dismiss.
- Understand the world's supply of "art materials" is endless.
- Listen.
- Explore.
- Extend.
- Transform.
- Do not need the teacher to "like" it.
- Look people in the eyes.
- Are not afraid of the inevitable "ugly" stage of art-making.
- Sit in silence.
- Obliterate shame.

- Risk.
- Brainstorm.
- Get lost (and found).
- Seek meaning.

A brave art paradigm requires students to find meaning in their own lives to make art about. It is interdisciplinary in nature. This means the materials and methods of production are unknown at the onset. At times, the teacher may lead or inspire the theme or subject of an experience, but he/she does not limit the possibilities of production. Olivia Gude provides inspiration for some art experiences in her article "Principles of Possibilities: Considerations for a 21st Century Art and Culture Curriculum." (1) These brave principles are ripe with meaty and relevant topics for a high school student to explore:

- Playing
- Forming Self
- Investigating Community Themes
- Encountering Difference
- Attentive Living
- Empowered Experiencing
- Empowered Making
- Deconstructing Culture
- Reconstructing Social Spaces
- Not Knowing

BraveART is work made by people who are willing to embrace mistakes as part of the meaning-making process. These mistakes come in the form of trial and error in the studio AND life and lead to transformation:

- Mistakes require risk. →
- Risk is the core of the creative process. →
- The creative process is both terrifying and exhilarating. It knows finding something new, unknown, honest, first-hand and authentic is inspiring. →
- Inspiration is often wise. →
- Wisdom can emerge from information deep within the BodySelf. →
- BodySelf knowledge is also called "intuition," "gut response," "creative spirit," etc. It is unique to each human, and meant to be trusted. →
- It informs Brave Art and, upon reflection, enables transformation. →→→→

TRUST
Brave Art has three main components: finding, making and reflecting. Each of these requires trust. Because "trust" is central to the BraveArt making process, this book teaches future teachers how to build trust structures. Without it, people will not risk making mistakes and the entire transformative process will die.

Teachers earn trust. The building of trust begins the moment a student enters the art classroom. Everything the teacher does from point of entry is under scrutiny via a student-trust-radar. The teacher must be trustworthy for students to contemplate creative and social risk – things good "art" asks of people.

Though trust structures begin with the teacher, it will ultimately be the GROUP (class) who has the most impact on the brave art process. Even if the teacher seems trustworthy, if the group environment does not feel safe then teens will not risk. Remember, we are dealing with teenagers. At this point in their development, they want to be a part of the crowd. It is very hard to be brave when standing out can mean being left out.

The high school art class thus hovers in between three worlds. First, there is a world with access to humans on the brink of adulthood who desperately want to grow up and find their voice. Second, these teens do not want to harm their social placement in school. Third, the subject is "art" and art [can] require/s risk. The teacher now has to decide what his or her vision is. Will she decide to use art to teach students how to make products, and thus maintain the status quo [=the easiest way to teach]? Or will she use art to help students bravely make-meaning in their life [=the harder, yet most fulfilling, way to teach]?

If the teacher chooses to use art as a meaning-making force, trust becomes key. Trust is reciprocated between teacher → student → art. Ultimately, it is art that extracts the voice, but the teacher has to allow it to happen and the student has to share.

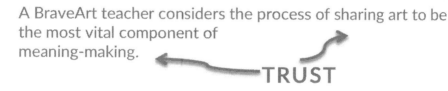

A BraveArt teacher considers the process of sharing art to be the most vital component of meaning-making.

TRUST

When thinking about what is important to teach in a high school, one might ask what is going to best help teens: knowing how to draw an apple well; or being able to conceptualize, contextualize, and verbalize? Likely, it is not the goal of an art curriculum to produce future artists. If it were, we would only be teaching to a small segment of the population.

All high schools have a few art students who seem to have promise in regards to making quality products. High technical skills have more to do with the student's initiative to practice than it does with his or her use of class time. For these students, the top art schools will have selective acceptance rates. But art school acceptance rates are not entirely based on product representations. University programs also look for passion, commitment, openness to new ideas, and an ability to articulate about artwork – things a high school art program that devotes itself to being brave can help ALL students with on varying levels.

The few art students who make it into art programs and build a professional portfolio for the art job/gallery circuit will still have a hard road ahead of them. Sixty-five percent of

artists are self-employed. The fact is, without an insane tenacity and dedication to the intention to make art, prowess in the business/promotion of art, and a stellar contact list, there is a good chance a self-proclaimed artist is not going to make it in the professional art world; no matter how nice his/her product is. Making it in the contemporary world as an "art star" gallery artist is akin to making it as a headline singer, model, or an A-list actor. The competition is stiff. Art stars affiliated with a "branded" dealer make up only 1% of all contemporary artists. In his book The 12 Million Dollar Stuffed Shark: The Curious Economics of Contemporary Art, Don Thompson tells us there are 40,000 artists roaming the streets of New York City as we speak—and

1,791,000 bachelor's degrees conferred in 2011–12 as:	
Business	367,000
Social sciences and history	179,000
Health professions and related programs	163,000
Psychology	109,000
Education	106,000
Art Education	1,414
Visual and performing arts	95,000
- Painting	600
- Sculpture	322
- Drawing	300
- Ceramics	209
- Printmaking	179

Data from National Center for Educational Statistics www.nces.edu.gov

2,500 of these people might have some representation in a small gallery while they supplement their income with some other means. This means that there are 37,500 starving artists in NYC alone! He states that most people quit their dream of "making it" as an artist by the age of 30.

If few students go on to art school, and the chance of making an art-star studio career is low, then WHY should art be taught in school?!

Elliot Eisner gives us a great list!

10 Things the Arts Teach:

1. The arts teach [people] to make good judgments about qualitative relationships. Unlike much of the curriculum in which correct answers and rules prevail, in the arts, it is judgment rather than rules that prevail.

2. The arts teach [people] that problems can have more than one solution and that questions can have more than one answer.

3. The arts celebrate multiple perspectives. One of their large lessons is that there are many ways to see and interpret the world.

4. The arts teach [people] that in complex forms of problem solving purposes are seldom fixed, but change with circumstance and opportunity. Learning in the arts requires the ability and a willingness to surrender to the unanticipated possibilities of the work as it unfolds.

5. The arts make vivid the fact that neither words in their literal form nor numbers exhaust what we can know. The limits of our language do not define the limits of our cognition.

6. The arts teach students that small differences can have large effects. The arts traffic in subtleties.

7. The arts teach students to think through and within a material. All art forms employ some means through which images become real. *to communicate* *in words*

8. The arts help [people] learn to say what cannot be said. When children are invited to disclose what a work of art helps them feel, they must reach into their poetic capacities to find the words that will do the job.

9. The arts enable us to have experience we can have from no other source and through such experience to discover the range and variety of what we are capable of feeling. *help us discover emotional intelligence: our range of feelings*

10. The arts' position in the school curriculum symbolizes to the *students* young what adults believe is important.

There are plenty of other books and studies that reference positive developmental and educational reasons for teaching art in school. Brain research confirms arts education strengthens student problem-solving and critical thinking skills, adding to overall academic achievement, school success, and preparation for the workforce. The National Art Education Association has many brochures and resources for teachers to pass out during an open house (which is a great thing to do for your program!), or just Google "art advocacy" to find a variety of groups/research that support the teaching of visual art. Some facts may include how art helps develop persistence and self-confidence; how it gives some students a reason to come to school; that it fosters leadership skills, etc. One study shows teens who have the opportunity to express themselves in creative activity have a means of reacting to the social environment in ways that are acceptable to society, and those who have found no way to create will react in negative ways. (2) This is powerful

stuff! The visual arts are also core components to the Habits of Mind, which are 16 attributes that human beings display when they behave and intelligently confront problems. The 16 Habits of Mind identified by Costa and Kallick include:

- Persisting
- Thinking and communicating with clarity and precision
- Managing impulsivity
- Gathering data through all senses
- Listening with understanding and empathy
- Creating, imagining, innovating
- Thinking flexibly
- Responding with wonderment and awe
- Thinking about thinking (metacognition)
- Taking responsible risks
- Striving for accuracy
- Finding humor
- Questioning and posing problems
- Thinking interdependently
- Applying past knowledge to new situations
- Remaining open to continuous learning

The authors of Studio Thinking (Hetland, Winner, Veenema, Sheridan) advocate that the visual art classroom specifically hones eight similar Habits, or dispositions: *Observing, envisioning, reflecting, expressing, exploring, engaging and persisting,* and *understanding art worlds.* They believe that once taught in the art room, these dispositions might transfer to other contexts of learning. (3)

Of course, these reasons for art are well and good, but they do not excite teens. Trying to convince a group of 30 anxious teenagers art class will be "one of the most important classes they will participate in" is a hard sell. These students have no idea what this statement means. More likely, they are taking an art class for 1.) What they think will be an easy grade, 2.) Because they think they might like it, or 3.) They need an art credit to graduate. They are not overtly taking an art class because they hope to learn how to brainstorm, work together, think aloud, trust their feelings, persist, expose social ideas, etc. Likely, they think the only skills they will learn include drawing, painting, sculpting -- they are unaware of the hidden curriculum.

On the first day of class, I try to provide students with logical and more profound reasons for being in art class. I warn new art students that, as Daniel Pink says, we have moved from an "information age" to a "conceptual age." In the conceptual age, the skills that involve *empathy, design, story, play, meaning* and *symphony* are as valuable (if not more) than the out-dated linear skills that can now be outsourced or automated (such as accounting, anything routine, information dissemination, etc.). (4) I explain we live within a construct that is eternally evolving, and they will need to see big pictures and be able to conceptualize possibilities to stay ahead. Therefore, in its totality, I tell these nervous students that "art class" is not about only about making things, but rather it is about making NEW meaning; thus providing humans with tools to help them become better people (and society to become a better society).

On that first day, I know emotions are festering all around me [see Appendix: First Day]. I tell students how I am aware most of them are nervous about being in a class that requires keen participation, but I hope they will be brave, try new things, and experience something significant before it ends. I provide them with basic benefits of such a class:

- They find a career path in the arts as a designer, studio artist, historian, teacher, etc.; or in business as an innovator.
- They learn to appreciate art and use it as a hobby, connoisseur or advocate.
- They find a special way to help them transform with life by being brave and confident with their new creative and communicative abilities.

. . . this is just the beginning!

A BraveArt EXAMPLE

While I was writing this book, I received a note from one of my former high school art students. She did not opt to use art as a career path, but she obviously uses it for her life journey—even as an adult. Her note stated:

> "...I'm working on trying to find how pollution from the UP mines affects the life around it! It has been truly amazing! I still think of you quite often and I do still pull out my paints from time to time. I learned so much about myself with your guidance in high school art class! I think that a lot of my ability to express my passions is due to being able to be in a safe and open space during art class. I still take much pleasure in releasing all of what I keep inside onto paper. Thank you for always encouraging me! " - Liz (5)

In high school, Liz worked on an environmental sculpture. For the project, she walked a local beach for one week and picked up litter. She then constructed (all on her own!) a plumbing system that brought water up into a showerhead and made it rain down onto the garbage in an attempt to advocate for pollution control. During the class critique, students brainstormed ways to recycle and reuse products around us. This piece (and the discussion that stemmed from it) inspired the class to begin recycling the art room paper. I, as Liz's teacher, had no knowledge of pipes or pumps and no access to wood frames or beach trash -- but -- I did give her the space and encouragement to make her vision manifest. Brave art teachers swallow his/her ego and say "Yes!" to the brave art student.

This example serves as a great reminder of how a brave art classroom steers away from emphasizing the visual product (her shower was not especially lovely). Rather, it focuses more on the SOUNDS that form from the art. These sounds help students not only for today, but also for their tomorrow. In this case, my former art student was able to find a career she is passionate about (environmentalism), and honed the capacity to express herself due to her days in high school art. By allowing this student to explore her world, she was able to find meaning beyond the classroom's border. Through group reflection, she and her art piece were able to "speak" in their own ways to a variety of people. Together, Liz and her artwork inspired change and community within our classroom. This is what Eisner means by, "Learning in the arts requires the ability and a willingness to surrender to the unanticipated possibilities of the work as it unfolds." Cathy Malchiodi, an

art therapist, knows that the voice of art comes in many forms, and often the conversations that stem from the art are most significant She states on her website, *"... when words are not enough, we turn to images and symbols to tell our stories. And in telling our stories through art, we can find a path to healing, recovery, and transformation."*

Here are a variety of other ways Cathy suggests that art can help with life transformations:

1. It helps express what words cannot.
2. It serves as catharsis (emotional release).
3. It helps make a product that is "special" (think Dissanayake!) and can be used in many ways (sometimes for therapeutic, magical, or spiritual effects).
4. It enhances and helps find meaning in life. (6)

SUMMARY

- The ability to learn from art, and thus each other, can emerge from hearing and listening to the art reflections and life experiences that students bravely share in safe and caring classroom atmospheres (things this book will teach the reader how to do).
- A brave art teacher focuses on creating meaning so that problem-solving/finding and thinking skills will be useful to students in a multitude of circumstances.
- Such a method of instruction (and learning) is based on a trust in art and humanness, which begins with the teacher/leader and eventually filters into the students.
- Under this philosophy, **brave art for teens** is not about making art objects. It **is about finding life-meaning via reflecting upon the art-making process.**

Brave Art in Action:
New Urban Arts.

New Urban Arts is an independent, non-profit agency that provides arts programming for adolescents, almost all of whom are enrolled in Providence's public high schools. Best known for its core academic year program, Art Mentoring, it began developing the model when four college students gathered a dozen high school students to collaboratively plan what would be the organization. It is a place where art Mentors with a variety of skills are clustered with youth in an open studio for two sessions every afternoon. The youth align themselves with the activities and Mentors according to their interests and needs. Intriguingly, New Urban Arts does not claim to teach art in the most obvious sense. Instead, it sees its mission as building "a vital community that empowers young people to develop a creative practice they can sustain throughout their lives."

All participants (Mentors, youths and leaders) serve to create a foundation for a vibrant and intentional community of practice – a space in which participants are known, feel safe, and understand that their voice, affinities, and questions are respected and heard. Learners are invited into art traditions and helped to develop the necessary creative and critical skills to succeed in achieving personal goals, regardless of whether those goals are aesthetic, social, or related to another sphere of human experience. In this way, the program enables young people to see creativity as a holistic dimension of their life and means, one among many, for creating meaning.

Meaning emerges when the boundaries of preconceptions are lifted and diligently supported by the place. Indeed, this place supports meaning-making. Upon entering the studio, the creed risk, leadership, inclusion, connection, voice is on display. This is a place where participants do not pass or fail, but rather, where the most valuable learning might emerge from failure.

Here, the teaching of art is not cast in terms of specific skills, but is rarely considered to be what it is: a key to social transformation. Such a program requires commitment and labors of teachers and other adult leaders to help students develop the habits and skills of freedom and self-determination ... while cultivating the ability to imagine a different and better world. Such a concept is the opposite of a normative art program that often justifies their existence through an economic lens – as a means of securing employment or as economic development. In both cases, creativity is seen as a means to a narrow (dead)end and not as an important human activity in itself. But, by connecting the lived experience with the practice of art-making, this program prepares urban youth for reparative roles in their communities – as artists, educators, activists and participants in an engaged community of problem solvers.

Excerpts from article titled "I Wish I Had a Place Like This When I Was Growing Up: New Urban Arts and the Cultivation of Creative Practice," by Peter Hocking. Radical Teacher #89. Pgs. 47 – 56. 2011.

BRAVE ART & TEENS

☑ RISK

☑ LEAD

☑ INCLUDE

☑ CONNECT

☑ VOICE

~ New Urban Arts League's Classroom Creed

I. The Art Teacher

Learning how to teach is like any other form of art—it takes time, discipline, faith, trust, and love for "excellence" to manifest. It is not an easy job. This book is written for the **potential** future high school art teacher. As an art education professor, I get a handful of students every term who question their career path. This chapter is meant to help potential teachers realize the overall demands of an art teacher. Here are some questions to contemplate:

- *Do you have the yearning to embrace this path?*
- *As a child, did you play "teacher"?*
- *Do you naturally go out of your way to help others?*
- *Do talk to the person no one else in a room talks to?*
- *Do you feel great joy when someone "gets it"?*
- *Do you ENJOY your art education coursework and find it to be interesting rather than just homework?*
- *Do you scour art education magazines, catalogs, texts, and resources with fervor and glee looking for great ideas for your future classroom?*
- *Are you curious about seeing the world's art in person?*
- *Do you feel a need to make art/meaning in your life?*
- *When you speak in front of groups, are you nervous because you want to do well—or are you truly afraid?*
- *Are you confident that your abilities as an artist and teacher will grow?*
- *Do you "watch" how other teachers teach and reflect upon it?*
- *Are you good at explaining things?*
- *Can you empathize with people?*

As a young art education student, I could easily and positively answer those questions. Most of my teacher friends also "knew" from an early age they would be teachers. My parents bought me a large black chalkboard and teacher texts before I hit 3rd grade. I spent the majority of my elementary recesses inside the school correcting papers for my teachers. I was born to teach. How about you?

I was not born an excellent teacher. Most teachers are mediocre (at best) when they begin their careers. The art of teaching is something that develops over time. Rookies say it takes at least five years to understand the job of a teacher. I believe this is a minimum goal. It requires much practice in both the art studio and the classroom to become an excellent teacher. In the end, I do think being an art teacher is a great way to unite life, work and art. It can be an incredibly rewarding career.

I had to learn how to integrate my art practice into my teaching practice. I believe the art teacher should equally see him/herself as a studio artist AND a teacher. To teach art well, one must delve into it. It requires a broad knowledge of studio techniques, technology, historical/cultural contexts of art, and the inner-workings of the art scene. But the art teacher must also be able to describe and teach these things to a variety of learners, have an understanding of the physiological and cognitive developments in humans, and know the lineage of both art and art education. Art teachers are not all "art" or all "education." They are Artist/Teachers. Being an artist makes the teacher a more credible teacher. Viktor Lowenfeld states:

> We are not magicians in the promotion of creativity. We cannot promote it unless we, ourselves are creative... It is like love; I can give you a lecture about love, but unless you have been shaken by love and been deeply in love, you won't know what I am talking about. (7)

Consider the skill it takes to teach thirty people a series of studio steps. Most people who create art have been making it at some level for a while and do not often think about what they are "doing." To them, moving paint around a canvas or balancing clay pots on a wheel are very natural acts. However, the art teacher differs from the studio artist because he/she must remember what it was like to learn how to make art and be able to empathize with the beginner. More importantly, he/she must also stand in front of a room of teenagers and verbally instruct and inspire students to create something meaningful without losing ONE student in the process.

> TO DO: Find a box and put it in front of a person who does not have "drawing" skills. Explain to this person how to draw a cube (without using a formula or drawing on his or her paper!). Notice how intensely one has to think about what instructions comes first to last. One must also anticipate what the student may misinterpret or do wrong and try to circumvent these errors. Now imagine teaching this same skill to 30 beginners in your classroom!

It is my experience that many art education students enter their first education courses not thinking about how they are going to have to speak to, command, inspire, and lead groups of people. High school art teachers cannot be shy or quiet people with the sensibility of the loner-studio-artist. The art teacher must be an extrovert on some level and be able to stand in front of 30 people and act as a leader. This, too, can be learned—but the shy person is going to have to learn to break through fear – and come out of the studio!

People contemplating the art education major should also consider his/her university course program. Art education majors often have to find ways to mesh art classes with education and general studies classes; find time to display art; make a portfolio; form a teaching philosophy; pass state certification tests; volunteer in the classroom. These tasks require more work of an art education major than many other majors on campus.

MY STORY

It is also easy to believe the rumor that nearly half of all new teachers quit within the first five years of their careers. I almost quit at that point in my career, too. Those were the hardest career years of my life. In the beginning, my students were unengaged. I did not have the insight to blame myself; instead I blamed the "bad" students, the administrators, and/or the parents. However, I was to blame. At that time, I did not know how to listen to the human voices of my students. I was teaching art classes exactly how I learned about art, and my students were not buying into it. I only began making progress in my teaching after I started trying new teaching approaches.

I made many mistakes my first year on the job. I had moved from Michigan to Indiana for my first teaching job and was away from a personal support system. Without any friends or connections in rural Indiana, I turned to my art studio for sanctuary because my classroom was chaos. It was here when I understood how the "art" I was "forcing" my students to do was nothing like the art I was doing in my own studio—though I had no idea what to do about it. Until that point, I had not understood that my students were not receiving a personal benefit from their art; they saw the class as unimportant. If I were going to succeed as an art teacher, I would have to make class relevant to my students.

It took me a few years to find a role model. Reaching out for ideas, I finally uncovered a text written by Peter London called No More Secondhand Art. This book was enthralling! Ironically, about the same time I began to study this book, I saw Peter was hosting a weeklong workshop at the Detroit Institute of the Arts, and I enrolled. That experience was what I needed. After the first day at the workshop, I understood Peter was someone special to "watch" and I had the insight to dissect how he conducted the workshops and made everyone engage with the group—without overt force. This is when and where I learned about the power of the group, and my teaching (and life) changed forever.

London is, "a skilled gardener who grows amazing vegetables and flowers... [lovingly planting seeds] to nourish the souls of others." (8) Indeed, by watching Peter London in action, I was studying a leader who was "practicing" the art of teaching. He did little things that made the group flourish. He sat us in circles rather than rows, learned participant names, talked to each one of us individually throughout the course of the day, listened intently, asked us questions, and allowed his students to lead and voice. By the end of the week, I understood how teaching "art" in the classroom could be more about forming meaning than making things, just like what I was doing in my studio... and just like Peter was leading/modeling in this workshop.

I returned to school in the Fall determined to try new approaches. I had to trust I could bring some of the magic I learned from Peter into my own classroom. For the first time, 30 stools formed a big circle in the middle of the art room to greet my new art students (circle-group was a practice I learned from Peter). I was so nervous about trying something as harmless (yet novel) as forming a circle-group that I kept moving the stools from row to circle and back again before the class started. It did not go unnoticed! Upon entering, I overheard one of the students say, "Oh no, Patterson turned into a hippie over the summer." I sucked it up and sat on one of the stools with my new group of students and

proceeded to introduce myself to the class. Thus, "circle group" began! It became the norm and students came to love it. In fact, they moved their chairs into circles for class discussions and critiques (which I began calling "reflections" due to Peter's workshop) without my prompting.

That semester, I understood how my students could/would be sympathetic and open to new ideas. With time, I also learned that some of my "great ideas" just would not work (Oh, I've tried some retrospectively silly things!), and how even the best teachers have bad days. The important thing is to confront failure and understand that teachers are eternal learners who continually try to improve efforts to best help student development.

As I continued my career as a teacher, I learned how helpful books about business leadership styles and psychiatric group-building methods were for classroom management. Sadly, education coursework rarely discusses these beneficial tools. My success as a teacher would have more to do with understanding leadership and the building of "group" than it would be about coming up with "projects" to recycle.

On another level, I understood I was not personally thriving in rural Indiana. I had to be brave enough to leave one tenure-track position for another, and I needed to find a school system that would provide me with nourishment. So I moved and tried a few different schools and realized each school has its own form of leadership, value structure, and community. In the end, I came to select jobs largely based on my potential colleagues. These are the people who will either motivate excellence – or feed negativity.

I have since worked in rural, urban and suburban areas and had televisions thrown at my head, watched a student be removed from class in a straitjacket and worked where a large percentage of the 7th grade girls were pregnant. I witnessed gang members ransack my room, and an entire classroom of children dive under their desks at the sound of a car backfiring (in order to protect themselves from random gunfire). I argued with a father who thought his daughter belonged in Home Economics (not art class) and with suburban schools that revered product, GPAs, and test scores more than creative thinking. Through it all, I learned teaching has a flip side to trauma. I have watched tormented introverts blossom and suicidal students gain strength. I have seen hope offered through the arts, this hope I trust.

After teaching in public schools for more than fifteen years, I became a university professor because I saw the significance of teaching teachers. As a high school art teacher, I was making a difference in the lives of humans—student by student—class by class. I began thinking, "Wow, what if I taught classrooms full of teachers who would then go out and teach classrooms full of art students?" This was a big shift in both my life and career.

As a university professor, I visited many schools and watched a variety of veteran teachers teach. I was surprised by how bored I was in some of the classes. Further, my new undergraduate students, who were fresh from high school programs, were ready to teach exactly how they were taught. Of course, that is what I did when I graduated college.

Getting caught in the "It worked for me" rut can harm education. My high school art program obviously "worked for me." I thrived because I loved my quirky and oh-so-sophisticated art teacher, and I was good at (and enjoyed) pleasing her. When I became I teacher, I was a Mini-Her. I soon learned that her tactics were not seen as relevant to students who were not like me.

Another example of "it-worked-for-me" comes when one thinks everyone derives motivation by what motivates him or her. I witnessed an art teacher tell an entire class of young teens how none of them can "draw" and they should stop trying. Afterwards, I respectfully asked the teacher what she meant by such a broad declaration. She replied that her studio teacher made students cry in class and it motivated her to work harder. From what I could see, her antiquated motivational techniques were not working for her unfortunate students.

Yet another example of "it-worked-for-me" is in regard to comfort zones. Often people push their likes and preferences on to others. On the flip side of this, they also push their fears. For example, if a teacher is comfortable with drawing but dislikes sculpting, he/she may not expose and/or allow his students to sculpt. Teachers cannot filter options to students based on preferences. Brave art teachers must be willing to try and learn new things alongside their students. Instead of saying, "I don't know how," a better retort is to say, "I can learn how."

The next big lesson of my career came while working as a studio art professor. My freshman undergraduate art students' were largely unable to abstract or conceptualize ideas. These kids were utterly unprepared for collegiate art classes, yet I knew my former high school students could have walked into these studio courses and hit home runs. I realized whatever I had been doing in the high school art classroom was very different from what these kids had experienced. Future art teachers had to be given new tools to deal with contemporary times.

ART TEACHER TOOLS

There are plenty of excellent idea-makers in art education's past and present that can provide new ideas for the classroom, but one must take the time to find applicable mentors and resources.

So who stashes the best art teacher tools? The National Art Education Association (NAEA) is a trustworthy association. It is the leading professional membership organization exclusively for visual arts educators. States generally host their conferences in the fall, and the national conference occurs every spring (fluctuating from east to the west coast). All future art educators should be a member of this association and attend the state and national conferences as soon as possible.

Throughout the year, the NAEA publishes a magazine and newspaper for members. Note the authors and read the bibliographies. These academics have their own personalities and beliefs – overt, angry, academic, mainstream -- and they are the "face" of art education. Look for their names in other articles and at the NAEA national conference. At the

conference, go to their sessions. It is at the national conferences where the scholars who "tag" the newest art terms (DBAE, Big Ideas, Elegant Problems, a/r/tography, etc.) present their work. When attending the conferences, high school art teachers will gain more insight to their practice if they attend sessions that do not revolve around "projects" and are not corporately sponsored by someone like Crayola.

The NAEA also houses "issue groups" to help people align to certain topics. Some of these include Caucus for the Spiritual in Art Education, Committee on Multiethnic Concerns, Art Education and Technology, Design Issues Group, Early Childhood Educators, Lesbian Gay Bisexual Transgendered Issues Caucus, Women's Caucus and more -- some are free, others are not. Some are active, others dormant. Maybe you are the person who can reinvigorate or establish a new group? Involvement matters.

There are plenty of resources that feed art education that are not specifically disseminated through the field of art education. Look for interesting people/ideas (alive and not) who work to empower people. I find a lot of classroom fodder in poetry, music, movie segments, philosophical quotes, etc. and spend a lot of time linking these to create lessons. There are plenty of pre-made lesson plans on the Internet, but always remember, just because a lesson plan is in a publication, it does not mean that it is a good choice for you or your classes.

TEACHERS
Now let us talk a bit about the actual job of a teacher. A teacher has many roles separate from "teaching." It is of benefit for the future art teacher to realize this.

All teachers teach students. It does not matter if they teach art, health, or science -- the job duties are similar and include menial tasks, social responsibilities, and professional ethics. Sometimes these things are not as glamorous as one may wish them to be. Teachers construct handouts, make photo copies, devise classroom activities, develop modes of assessment, provide feedback formulas to students, generate overall curricula that meets state standards/objectives, write and submit lesson plans, take attendance, mark a tardy, and produce/grade examinations. Teachers also attend parent/teacher conferences, faculty meetings, proms, sporting events, and open houses; they spend their evenings grading, mopping classroom floors, budgeting supplies, collecting materials, asking for donations, preparing lessons, borrowing and giving. Like it or not, teachers also wear what I call "ugly teacher clothes" and must appear professional at all times. In other words, the job of an art teacher is not just about making (or teaching) art.

A teacher is a teacher outside of the classroom. If one lives in the community where he/she teaches, there are social responsibilities that come with his/her behavior outside of school. This includes in the social media realm, too. Stories are emerging of teachers getting fired for inappropriate images (photos of "Mrs. Smith" doing shots in a bikini) on sites like Facebook. Some schools ban teachers from being on these sites.

Teachers also need to be adept at keeping appointments and time. Compared to many of

my friends who work in business or other sectors, I seem to have a hyper awareness of "time." I am generally the first person to show up at a party or a meeting. It is ingrained in me that I cannot be late. I realize it may sound like a trite piece of information, but being on time to work is a vital requirement of a teacher, and this is something my non-teaching friends do not have to worry about as much as I do. Frankly, it is something the majority of my art education students have not fully considered. Teachers cannot be late to work. Period. Art education students must begin learning how to schedule their time. Practice being on time: buy a watch, be early to meetings, pay attention to how long an hour really is, carry a calendar, submit all coursework on time.

Being healthy is also important to a teacher's career. Undergraduates who are struggling with health issues need to find ways to cope with his/her health. Teachers do acquire sick days, but excellent teachers rarely use them. Make it a habit to wash hands, spray Lysol, and pay attention to your vitamin intake. Exercise. Learn how to cope with stressors. Experiment with ways to stream-line life before life becomes too hectic.

Teachers need a variety of dispositions to be "good" teachers. The National Council for Accreditation in Teacher Education (NCATE) Online Glossary has the following definition:

> **Dispositions**. The values, commitments, and professional ethics that influence behaviors toward students, families, colleagues, and communities and affect student learning, motivation and development as well as the educator's own professional growth. Dispositions are guided by beliefs and attitudes related to values such as caring, fairness, honesty, responsibility and social justice. For example, they might include a belief that all students can learn, a vision of high and challenging standards, or a commitment to a safe and supportive learning environment.

Five commonly held dispositions of a good teacher are: *empathy, positive view of others, positive view of self, authenticity* and *meaningful vision of purpose.* The most critical characteristic of a teacher might be empathy. Empathy is an awareness of what it feels like to learn something new while accepting as real what another person is going through. Empathy requires a commitment to sensitivity and the establishing of relationships with a learner. The scholarly knowledge of the teacher, mixed with the human experience of a student, can only be done at the "excellence" level if/when empathetic integration occurs.

The more a young teacher understands the expectations ahead, the more she will not be surprised by the fact that "teaching" is merely a fraction of what it means to be a teacher.

TEACHING
Teaching is the "teachers" profession. Teaching involves not only empathetically recalling what it feels like to learn something new, but it is the actual action of outlining for groups of people how to silence doubts, inspire steps, pave ways for understanding, and engage with both content and the class/group.

Students learn at different rates and different speeds. Teaching involves knowing how to

share information with a variety of learners. For instance, a teacher may know how to draw an apple, but he/she must also know how to teach students, all who have varying abilities, how to draw an apple – and motivate 30 people to want to do so.

Teaching requires synthesizing all of the content materials made by the teacher (as mentioned earlier) and delivering it to the students in dynamic (and latent) ways - using varied instructional skills. The methods of delivery are not necessarily dependent upon the content but are rather dependent upon the students needs. Such methods might include acting, moving, dancing, nurturing, caring, laughing, disciplining, reading, drawing, questioning, answering, being aware, observing, listening, and/or sensing... Sometimes, teaching demands that one person do many of these things at once. It involves the honing of the individual AND the group—often via processes that are not overtly evident to the group. Teaching takes practice.

Overall, teaching is an organic-yet-linear process whereby a teacher selects learning goals, connects past with future goals, and then extends student thinking. The more a teacher is aware of this teaching process, the more he/she can "ladder" (build concept upon concept to reinforce ideas) information to help students expand. For example, in art we teach line before shape; value before texture; black/white before color. Perhaps this ladder building is the core of teaching praxis; however, if there is no awareness of how people learn best, the potential for student disempowerment is high. Remember: teaching methods can either empower or disempower students.

MAKING
On top of everything mentioned, what teachers do at home directly impacts their abilities in the classroom. It is important for the teacher candidate to realize they need to learn how to make time for their studio work. It is possible to find a balance, but young teachers will have to make attempts while also learning to tend to their "person." This means they must explore, risk, and live fully within their personal lives so they can better witness (and empathize with) struggles, problem solving/finding, discoveries, re-inventions, re-creations and the successes of their students. Excellent art teachers stay fresh and creative and can "mine" life experiences. In kind, they will be better prepared to push students to do the same.

Such risk takes "practice." Stephen Nachmanovitch, in his book titled Free Play, states that "practice" can be more empowering if we do not think of it in the Western "practice makes perfect" context but rather consider it as "practice as a way of life," like Eastern thought advocates. This means integrating life with practice—art with work—and not seeing being a teacher as a "job" but rather a synthesis with life and living.

Being a teacher and teaching teens is not an easy job—especially the first few years. As I mentioned, it took me a few solid years before I improved in my teaching abilities. Back then, "teaching moments"—the moments when I made a "pow!" difference to students—were few and far between. These few "moments" came in just enough intervals to entice me to stick it out and learn how to solicit more joy from my job. Eventually, the years I

spent teaching high school art became some of the favorite years of my career. I came to see teenagers as being ripe with idealism, needs, ideas, and passions. In the end, it took an unyielding faith in the arts to learn how to have faith in my students.

LEADING

I like to think of teaching as leadership manifested. Beginning teachers must be able to visualize themselves as leaders in a classroom. Teaching takes on variable roles of leadership that waiver between authoritative *(dynamic)* and laissez faire *(latent)* styles. The same teacher can use both styles of leadership. The trick is to know when to do so.

> **Dynamic.** The "dynamic" leader uses his/her authoritarian skills to uphold his/her vision. He works to build pro-social groups with the goal of shaping students to be confident in their individuality. However, dynamic leader can stifle creativity if he/she is too rigid. Dynamic leadership occurs when there is a concern for safety, during examinations, when goals must occur and/or when art (or an art student) needs defending.

> **Latent.** A latent leader shifts control to students rather than act as an authoritarian. Here, students are able to take responsibility for their work and respectfully take the center stage from the leader. In this capacity, the teacher's behavior is more that of an advisor. He/she depends upon both the content of art and students to shape the learning.

Daniel Masi, a former art education student of mine, who is now an Artist/Teacher, has eloquently reflected upon the idea of leadership:

> *"I have found giving up power, without losing the role of being a teacher, to be extremely powerful. The first thing I had to give up was saying to myself, and my classes, that 'I am the only artist and art teacher in this room and I KNOW WHAT ART is.' I know what art is for me, but how can I know what art is for all of the artists in my classroom?*

> *The second power I had to release was the superiority of claiming to be the only art teacher in the room. Yeah, I have done a lot more art than most of these students and went to college and earned some degrees; however, that doesn't eliminate the possibility of my students being my art teacher. I tell my students that they teach me as much as I teach them. It is a symbiotic relationship—we propel each other to expand the limitations placed on ourselves as well as the limitations set by others.*

> *By [being a latent-leader] I empower my students with the understanding that THEY are artists and THEY are teachers. In turn, I empower myself with the same. This is an important ingredient in a nurturing and creative classroom."* (11)

Sometimes beginning teachers have a hard time seeing themselves as "leaders," and this

puts them at a disadvantage while forcing teenage students to arm wrestle for leadership status (which can lead to chaos). Education courses, unfortunately, rarely teach leadership skills, what leaders do, or how one becomes a leader. However, business classes readily teach this, and in the end, it is helpful to think of what it means to be a leader:

1. Vision (long-term and short-term).
2. Passion (for content/art, teaching, and students).
3. Ability to communicate a vision.
4. Tenacity to work toward something of importance.
5. Ability to convince others of the importance of the vision.
6. Confidence in others (and content/art).
7. A keen sense of community.
 (Note some of these characteristics are from Rita Irwin's book Circle of Empowerment, pg. 26).

Who are leaders? Teachers of Sushido explain leadership eloquently: *"Certain people show up in the world in such a way that others are willing to trust and follow them, knowing that doing so will explain our own horizons as well."* (9) Peter Senge, author of business leadership books, states that there are three roles a leader plays: *designer, steward,* and *teacher.*

The leader as a designer is the person who adheres to the purpose, vision, and core values by which a group should function within. In essence, the leader's task is designing the learning processes so people can deal productively with the critical issues they face while engaging in learning opportunities. In the classroom, this is the person who fosters respect and models communication values.

The leader as steward gives meaning to their work through a unique relationship to his or her own personal vision. He or she becomes a steward of the vision. Stewardship involves a commitment to and responsibility for the vision, but it does not mean that the leader owns it. It is not their possession; rather, it is their task to manage it for the benefit of others, or "choosing service over self interest." Stewards learn to see their vision as part of something larger and allow the vision to change with the group's needs.

Finally, *leader as teacher* is not about "teaching" people how to achieve their vision; rather, it is about fostering learning—for everyone. (10)

VISION
Notice I placed "vision" at the top of the list of leadership qualities above; this word has already emerged within this book several times and warrants an explanation. A vision is a focusing of energy towards the mental image of what a goal looks like. Imagine a "perfect" art classroom—what comes to mind? This vision is the thing that provides teachers with strength when things go awry. It is a belief in what the classroom can and WILL be. Such physical imagining is called visualizing; also known as positive thinking, positive imagery, dynamic imaging, etc. It is ancient knowledge that the power of thought, imagination, and will changes circumstances. Visualizing helps a person to organize the resources necessary

to achieve a goal or task.

How, as the leader, can vision be achieved? Vision is a process that takes time to achieve. It takes discipline to clarify and deepen a personal vision. It requires the focusing of energies towards developing patience and requires an objective view of reality.

I believe it is important to stress the idea of leadership to future high school art teachers because I have heard so many of them say, "But why should a teen listen to me? I'm only a few years older than them." Such an attitude, or lack of vision, only sets one up to fail. High school students will immediately sense the lack of authority and abuse the situation. Remember, authority comes in a variety of wrappers (dynamic and latent), but confidence is black and white: it is there or it is not. A teacher MUST BELIEVE in what he/she AND art offers. If the confidence is not there in the beginning, fake it until you not only "make it" but "become it."

THE ART TEACHER STEREOTYPE

The art teacher has plenty of stereotypes to contend with – not only about what one does, but about art itself. With each new school district I've moved to, I've had to contend with varying ideas about "what art is," how people thought it should be taught, and even what an art teacher should be —these are hard stereotypes to contend with! In some places, parents wondered why I was not making pumpkins at Halloween; others wanted the focus to be on realism/still-life art making; some parents had a difficult time understanding why their children had to show up for art class at all.

It is typical to think of art teachers as female clog-donning craft queens who are "artsy-fartsy." That they love the extra school work of making play sets, homecoming floats, bulletin boards, get-well cards, picking out wall-paint colors or even wrapping packages for colleagues. Few colleagues see art teachers as "artists," and, unfortunately, art teachers contribute to these stereotypes when they do not maintain an intense studio practice, exhibition record, or art-life outside of the classroom.

Society perpetuates the problem by not requiring tenure-track high school teachers to exhibit their work for promotion. Furthermore, undergraduate university art programs still largely separate art education and fine art students, or they do not expect the same quality of work from art education students as they do from Bachelor of Fine Arts seekers. Sadly, some universities do not require that an art education major take content-specific methods courses. Perhaps even more alarming is the fact that most university art education professors need a PhD, but no more than three years of teaching experience. Remember, it takes five years to begin learning how to teach even mildly well. These requirements (or lack thereof) leave many future art teachers with little, to no, resources (minus what they already know). Indeed, contemporary art teachers need to abolish the old stereotypes about art, art education students, and art teachers by being prime examples of excellent artists and teachers.

Dear _____)

- *It takes time for a teaching practice to develop.*
- *The first five years of teaching will be difficult.*
- *I will need to learn the historical, cultural, developmental, and technical components of art education and art.*
- *I must learn to talk confidently and comfortably in front of groups of people.*
- *I must be able to break down information, so people can follow directions and feel enough success to ultimately feel brave.*
- *I will need to find time to make my own art and tend to my personal life in healthy ways outside of the classroom – which will take effort.*
- *It'll be my responsibility to keep up-to-date with the degree program and the requirements of all the departments (and state) involved.*
- *I don't have to teach how (or what) I was taught. Though it obviously worked for me, it likely did not work for everybody.*
- *Some of my ideas will not work as anticipated, but that is okay. I won't give up.*
- *Schools have their own culture, and I will need to find one that "fits."*
- *It is my responsibility to keep abreast of what is new and powerful in the field of art education.*
- *Teaching art is not the only job requirement of being an art teacher.*
- *I will be expected to be on time and attend a variety of events on my own time.*
- *I have many stereotypes to contend with as an art teacher.*
- *Being an art teacher, and teaching art, can be an amazing job - with a little perseverance I will do great things in this world.*

"Fake it until you become it."

II. The Art Student

Students who identify with the term "creative" are often:
- **Individualistic.** They like to find out for themselves if something works or not—they are not comfortable following the pack.
- **Unconventional.** They don't need to conform to the conception of a "societal standard."
- **Driven.** They are INTRINSICALLY motivated by knowing and seeing and often work obsessively.
- **Visionary.** Creative people will work long and hard to bring vision to life.
- **Intuitive.** They "trust their gut." They are good at listening to their instincts and are fine with not knowing what the end answer is.
- **Curious.**
- **Solution-oriented.**
- **Opinionated.**
- **Playful.**
- **Willing to take risks.**
- **Judgmental of selves.**
- **In need of acknowledgment.**

Unfortunately, some high school content-area teachers are not comfortable with students who are unconventional, visionary and opinionated. However, the art teacher often wants to embrace these qualities and are comfortable with components of disorder: the unknown, risk, and maybe even messiness. People brought up in environments that allowed for disorder, curiosity, impracticality, or time wasting are likely to permit themselves to create, chance, waste, get dirty, play, and enjoy the art making process. Many students who confidently come to art class have parents who encouraged them to draw, play, build mud houses, act, use their imagination, make Halloween costumes, etc. Others are petrified of "art" and we will talk about the fearful students later in this chapter.

GIFTED/TALENTED
Aside from the few teens that enter the class already feeling creative, a student with an above average ability in art might be in the mix. This person might be considered to be "gifted" or "talented" - or both. Gifted people have great natural ability or intelligence. Traditionally, one intellectually gifted when his or her Intelligence Quotient (IQ) falls above 130. Giftedness is said to be an indication of a child's potential for high achievement in the future, both as a child and adult. The term "gifted" refers to the innate exceptional ability of a person, whereas, the term "talented" refers to the exceptional performance of a person. Talented pupils are those who have abilities in art and design, music, PE or in sports or performing arts. In some cases, a person will be regarded as gifted as well as

talented. Talented people tend to view the world with "artist eyes." This tendency might include that they:

- are sensitive to color
- notice how light affects things
- see things others miss (colors of leaves, shapes of clouds)
- enjoy drawing or making things
- are able to "get lost" in art and lose track of time
- can begin a project again if something goes wrong
- are curious
- like to solve problems, and will see projects to fruition
- keep an open mind about unusual forms of art
- like to experiment with new materials
- set aside time to create
- will meet deadlines

Importantly, one needs to understand the difference between a bright student and a gifted student. Ianic Szabos explains here:

Bright Students vs.	Gifted Students
Knows the answers	Asks the questions
Interested	Extremely curious
Pays attention	Gets involved physically and mentally
Works hard	Plays around, still gets good test scores
Enjoys same-age peers	Prefers adults or older peers
Good at memorization	Good at guessing
Learns easily	Bored - already knew answers
Listens well	Shows strong feelings and opinions
Self-satisfied	Highly critical of self (perfectionistic)

Source: Janice Szabos and http://www.tagfam.org/whoisgifted.html 2/1/11

Using a broad definition of giftedness, a school system could expect to identify 10% to 15% or more of its student population as gifted and talented. Typically the 6 types of giftedness includes:

Type 1. The successful = about 90%

Type 2. The challenging = divergently creative, perhaps unidentified GT

Type 3. The underground = hide their "gifts" to fit in (usually female)

Type 4. The dropouts = feel rejected by the system

Type 5. The double labeled = gifted, but emotionally or physically handicapped

Type 6. The autonomous learner = makes the system work for them

Teachers can help gifted and talented students in the following ways:

- Encourage independent projects.
- Help find competitions and symposiums in which to participate in.
- Find him/her a mentor (don't turn the student into a teacher's aide).
- Provide opportunities for discovery, rather than regurgitation.
- Have high expectations.
- Use terms such as compare and contrast; design; develop; rank; assess.
- Don't require "more" work (like additional papers), just deeper work.
- Provide opportunities to take part in other people's learning, both appreciating it and criticizing it.

CHALLENGED STUDENTS

Tips for the "Inclusive" classroom include:

- Provide high structure and clear expectations.
- Capitalize on the student's strengths.
- Use short sentences and a simple vocabulary.
- Provide opportunities for success.
- Allow flexibility in classroom procedures (e.g., allowing the use of tape recorders for note-taking and test-taking when students have trouble with written language).
- Present information and instructions in small, sequential steps and review each step frequently.
- Take photographs of steps for the student/s to view.
- Take photographs of the "rules" – how to put away brushes, etc.
- Provide prompt and consistent feedback.
- Modify/adapt materials as much as possible – keep pencil grips, modified scissors or stubby paintbrushes on hand. Use large foam curlers, sponges and add textures to paints and paper with glue, sawdust, sand, etc.
- Be sure to keep a stash of rubber gloves on hand for student who is tactile defensive against clay, cotton, nylon, plaster, dirt, or whatever it might be.
- Realize that 7% of the male population cannot distinguish red from green. (Only .4% of women cannot do this!)

FEARFUL STUDENTS

High school art classes are not only full of creative and gifted humans, but also fearful ones. It is an enormous task for an art teacher to break through the cultural barrier that equates art or creativity with mistakes or ineptitude—or more horribly—with a "right answer." Fear prevents people from giving primary emphasis to the perception of what is new and different.

These students fear not only risking or making a mistake, but they also fear speaking aloud, judgments, feeling inadequate, not living within a societal mold, giving up control and transforming into something that is not known.

Fear can be a powerful contender, and teaching humans to risk making mistakes is a tough sell, especially to someone forced to take an art class. If a student does not "feel" creative,

he/she is going to harbor some animosity toward a teacher and group that is asking (or allowing) her to make mistakes within an arena toward which she/he feels no affiliation. Feelings of inadequacy and fear manifest in negative behavior patterns if the teacher is unaware of them. Remember, empathizing with a student, discussing how far-reaching creativity is (Scientists and doctors are creative people too!) and logically outlining the creative process mentioned later in this book, will work in favor of a teacher who is trying to help students explore creativity without fear.

Throughout my years of teaching, I've come to notice fear will be exhibited in one (or all) of three common defenses. These defenses are under the umbrella of one major fear: not being good enough. These fears create the *fatalist, perfectionist,* and the *reverter.*

The Fatalist. The "fatalist" would rather throw something down on a paper and then bad-mouth the assignment/teacher/class rather than risk trying to draw or make something that he/she thinks will not turn out well. This fatalist approach can harm an entire class if the teacher does not find a way to ensure some success. However, it is extremely important that, after some success is made, absolutely no ridicule comes upon his/her work. Provide this student with small, detailed, and easy steps that lead to success. Do praise attempts and try to circumvent the negative energy with positive class encouragement.

Perfectionist. The "perfectionist" is not a risk taker, and this innate characteristic will diminish his or her motivation to attempt anything new. This student might restart a drawing over and over, continually erase, work exceedingly slowly to avoid making a mistake, or draw so lightly that it can hardly be seen. He/she often succeeds in academic classes where he is told what to do: "Put your name in the upper right hand corner." "Sit down." "Copy this." Asking such students to deviate from this style of teaching can be frightening. The grading of art can be subjective, and this subjectivity frightens the student who obsesses over his/her GPA. In the end, it IS the grade that is important to this person—not the process. With time, the perfectionist will see his/her art grade is not based on "right" or "wrong" and will come to trust the teacher before trusting him/herself with art. The teacher will have to remain patient and honorable while coaxing the perfectionist into creativity.

Perfectionists want answers. A tactic to encourage independent thinking includes repetitive answering. When students ask "How big should it be?" or "Where do I put my name?" I reply with a simple, "Wherever you wish" and repeat the exact phrase over and over until students understand it is their choice. The "wherever you wish" strategy works after presenting encounters or during other moments of creating too (it is one of my favorite phrases). Ensure that students understand this method helps them be creative and independent thinkers, because they may think you are being flippant at first. Mostly, students need to feel their "grade" and emotions are safe if they are going to risk, attempt, try, feel, or explore something new. Remember, few people in their lives are allowing (or asking) them to think on their own, or to be brave.

Reverter. Lastly, the "reverter" is the student in class who ONLY draws cars, horses, anime, etc. (and probably does so quite well). This student probably became good at the subject because he/she was lucky enough to receive some praise about his/her art. Upon hearing that they did something well, they draw the same object again (and again, and again, and again) and will continue to be praised for their work. Soon, they become known as the person who draws "horses" (or whatever it might be) and will affiliate with this title. Unfortunately, their "fame" will hinder their progress towards trying something new, else, or different. (Much like style work of a professional artist.) These artists then continue to choose the "horse" path, because they already acquired a reputation for being "good horse artists." They will not want to risk making something else because they might not be "good" at it – and this fear of failure will paralyze progress. The art teacher has to be aware of the fortified ego facade when trying to get the reverter to expand or explore new ideas.

A reverter can easily turn into a fatalist, and become quite a discipline problem (and the parents too), if prodded too hard to deviate from the norm. Gently try to coax new imagery out of them; sometimes just saying, "Try 'x' and if you don't like it, you can go back to 'y'." Also, if the student is mature enough, discuss bringing the concern to light and see what he thinks about it. Teachers can help these students by using creativity sparks in the form of icebreakers, Surrealist games or quick exercises.

Overall, a teacher can help a variety of students overcome fears by providing vocal encouragement, personal attention, a defense against any harshness in the room, and honor silence if a student is attempting to risk but doesn't necessarily want to talk about it at the moment. Defending against harshness and honoring silence are the two biggest shields a teacher can offer students who are not ready to let their peers get close to them. Art can be very personal. Students fear rejection, disapproval and gossip outside of the safety of the art classroom. As one student courageously shared with me, "It is hard to be brave in high school." (12)

"It is hard to be brave in high school."

Brave Art in Action:
There is no ~~Dis~~ in Ability.

Bronwen Tagoe, 18, paints contemporary abstracts. Tagoe was born without eyes and remains sightless.

"From things people describe to me and from things I have explored with my hands, I make a painting by using my imagination," Tagoe said. "It's fun to get my hands into different materials I use to paint. Painting with sponge and palette knife are my favorites right now, and of all the textures I work with, sand is my favorite so far." Into her paintings go all sorts of texture: rock, sand, cheesecloth, aluminum foil. Tagoe also builds texture with the use of modeling paste, patterns and stencils. Primarily, the paint has been acrylic.

Bronwen takes private lessons from Christine Goldbeck, an artist and gallery owner. "I've been teaching Bronwen for over a year now. Her mother, Deb Kersey-Tagoe, emailed me late last year after seeing my work on the web and noticing that I was a painter who did a lot of work with texture. Bronwen, of course, feels her way into and around a painting. So, texture is important," said Goldbeck, who is also a photographer, painter and author.

Goldbeck also credits Bronwen's mom with being a major reason for her student's success. Creative in many ways, Deb Kersey-Tagoe is an advocate not only for her daughter but for other sightless people as well. Kersey-Tagoe runs Braille-A-Wear, a business that features a line of clothing to promote awareness of Braille and blindness. Kersey-Tagoe encourages Bronwen to remove "dis" from "disability" and to concentrate on her abilities to do things differently. When we are working on a painting, I explain color by temperature and emotion. I say things such as 'this is a warm, happy green' and 'this red is cool and conveys a feeling of anger.' As for how we work a canvas or paper, I direct her by saying things such as 'I think your upper left quadrant could use a little green to balance this piece.'

Brownwen's favorite color is green. Bronwen sees through temperature, smell, sound, and through learning from others who understand that a person who is blind sees in ways of which so many of the rest of us are ignorant. Green is the smell of summer grass. It is a warm spring day; the sound of birds chirping from their perch in a budding oak tree. Green is the sound of water running over mossy rocks. Green is possibility. Green is whatever Bronwen sees it is in her heart and we are fortunate to see what she feels about green. Each time we begin a new painting, I ask Bronwen what color she is feeling. If she says "green," we talk about cool greens and warm greens. She listens as I discuss color issues such as value and tint. Last week, as we started a mixed-media painting on paper, she was feeling purple, a reddish purple into which she dipped a button stamp block that she made the week before. Color is meant to be felt and Bronwen is showing me how to better feel the colors on my own palettes. In summary, Goldbeck says, **"We empower each other."**

~ Christine Goldbeck

"We empower each other."

III. The Art Group

When the teacher, the "creatives," the gifted, the challenged, and the fearful all come together they must learn to trust each other! This is where teaching becomes an art form. The teacher makes a class full of diverse humans become a "group." The goal is to form a group of brave students to share their thoughts about art. Sharing is the root of brave art.

Groups are an invaluable resource for teens. They elicit a sense of belonging. Groups bear witness and provide affirmation. Because of the importance group plays on teens, it is vital that the goal of turning a class into a "group" is perceived as a worthwhile investment to the participants. Teens are not likely to forgo peer pressures to form cohesion with such a diverse group. Cohesion refers to the strength of the bond uniting the group, and that bond often depends on the teacher's leadership skills. All classes will have their own personality and timeline to achieve cohesion. It takes TIME to establish cohesion.

GROUP COHESION

A classroom can be collective commons. Commons refer to resources that are collectively "held in common" between populations. A place such as this has the potential of emerging to be the favorite place of many students. The success of the emergence has to do with the relationship between the teacher, student and content based on trust, respect, empathetic understanding and acceptance. "Group cohesion" is what happens when several single bodies come together, form a bond, and work together to reach a goal. In the case of the art classroom, the goal might be to support each other in their attempt to create new and interesting artworks while learning what it is to become more human. Leaders maintain a slow and steady vision toward making cohesion happen.

By now it might be obvious that the path to group cohesion is not always an easy one, and surely some behaviors will need to be circumvented. A desire to dominate is a prevalent mode of behaving when some new students enter a group structure, and the teacher must be prepared for such rebellion. One of the most important things I can tell new teachers is the following: if a student tries to ruin the vision for the group—it is a teacher's responsibility to NOT let it happen. It is the teacher's bravery that will pave the way for the other students in the group to flourish. The teacher MUST stand up to problem students (overtly or subtly), which means he/she is standing WITH other students. Teachers are the defender of all the other students in the room. (This is where leadership and visionary skills are most needed.)

ART DYNAMICS

The art classroom variables are as complex as the population of the group. First, everyone

has some "opinion" of what an art class will be (and maybe should be) and these students have already formed various affiliations with the term creative and artist – in both positive and negative ways. This means the initial class is full of ego, fear, curiosities, trepidation and probably some excitement. Clear hostility can also be present. Furthermore, recall students take an art class for many different reasons: for credit, fun, to learn, waste time, etc. Yet many students who willingly enroll in an art class do not feel like they are "part" of their school. Data indicates that as a group, art students are higher in flexibility and less well socialized, more impulsive, and more unconventional than the general population. (13) These factors hone a predisposed feeling of otherness and isolation and can cause animosity during the beginning of the year.

Additionally, the art class dynamic contains odd physical dynamics of space: paper cutters, sinks, enticing supplies, stuff on the walls. This environment brings students further out of their comfort zones, and puts their emotions on high alert. The structure of an art class is also dissimilar to that of math, science, or history -- where a teacher's curriculum stems from a textbook and students sit in their chairs and quietly listen – rather than actively share. With so many anomalies, art class is mysterious to everyone.

The uncertain students will go through a process during which they will watch and decide if they can, or wish, to become involved. If the students do decide to interact with the art experience and/or class, it is not because they have been talked into it, but because they've decided to take ownership in the process, which involves an emotional investment.

Given all of these contentions, few new art class students will realize they are about to encounter a "game-changing" event in their lives. The art teacher who is standing in front of this nervous group has her own secrets bubbling beneath the surface -- she knows what she is up against -- but is nevertheless bursting with hope. The students do not know about the egos or fears harbored around the room, or that the teacher is subtly (and masterfully) soliciting creativity from them, nor do they realize how predictable their actions are. They have no idea how significant this group will become to them by the end of the term, nor do they know how important they will be to the group. They do not know the art teacher is setting a stage – doing little things so they might do great things – or that she has a clear vision, heartfelt determination, and the patience of Job to turn this awkward class into a meaning-making machine!!

FORMING GROUP

There is no direct "method" to prescribe for the goal of forming a group. Every day, as the leader of this group, the teacher will place stepping stones of trust and expectations for students to walk upon – each one requiring more courage than the other. Meshing a group is a manipulative performance because a teacher comes to learn "x" action will lead to a "y" result. Immediate tricks include:

- Standing in the doorway when students enter forces every student to acknowledge the teacher's presence.
- Encouraging everyone to sit in a circle so they are part of a group, even if they say nothing to/in the group at first.

- Calling students by their names to make them feel "known."

A leader can tell if cohesion is happening when students begin to say things like, "This class is the best class of my day." "I don't want to leave this room and go out there." Trust is the key ingredient of cohesion. Here are a few other simple ways of leading a class in the pursuit of building trust:

1. Maintain eye contact.
2. Disclose personal tidbits slowly and appropriately: pets, kids, art studio triumphs, etc.
3. Encourage attendance (for both teacher & students).
4. Honor silence.
5. Consistently expect great things.
6. Model these behaviors.
7. Never "put down" a student – even if in "fun."

ADAPTIVE SPIRAL
An interesting component of building a group is a complex mirroring process that psychiatrists call an "adaptive spiral." Within this spiral, group acceptance increases each member's self-worth, and in turn, each member becomes more accepting of others and the class. The spiral happens quickly after one person in the group shows bravery. This may be in the form of sharing something significant with the group, or even by an act that is in defense the group. Once a person makes a step forward, other people see that it is "okay" and they move to join the group. People buy into the group rather quickly after a few people do. Noticing and valuing when this happens is important. The balance can be fragile at first, but if the teacher acknowledges and promotes it, it will get even stronger. To repeat, such a thing does not happen overnight.

RE-GROUPING
Be aware of the psychological notion called "re-grouping" that can happen within a group. This is especially risky in an art room, where the environment is less traditional than other classrooms. This term describes the smaller groups that form within an already small group. Potentially, this smaller group can gain more control over the larger group and increase the risk of negative peer influences. A leader recognizes this potential and fosters experiences that bring everyone into contact with everyone else while maintaining a sense of psychological safety and stability. For example, sometimes I walk into the room and say, "Okay, everyone must go sit next to someone they don't know very well and remain there for a few days." This allows students new experiences while dismantling any cliques.

GROUP INTERACTIONS
I repeat: the success of the art class depends upon on the GROUP. **The group has the power to trump the teenage individual.** Therefore, group building will be the key to fostering brave art

Recall that the focus of a high school art class is to bravely make meaning and to use that meaning to help navigate the ongoing transformation from teen to aware adult. Discovery

of meaning often comes after making the art. It is during these reflection times when teenagers begin a process of incubating real change. Change begins when people talk about things they care about (which emerges in art forms) and then make a determination to risk moving ahead. During reflection time, teens talk about their personal growth, healing, self-discovery, empowerment, expanding creative self-expression, identifying life purpose, and setting and achieving personal or professional goals. So the teacher needs to learn how to plant opportunities to make it safe to do so.

Education courses do not typically teach group-building skills. I had to study literature from business leadership and group therapy to learn a few tricks. Therapy is similar to education—it invites people to listen, voice, and grow. Like therapy, education can be an effective catalyst to change if it circulates between the acts of respecting, listening, questioning and conversing. On one level, these conversational notions are basic actions, but on another level, they require a deep attempt at mindful living to accomplish. Saying this, it is important to remember that the intent of the patient/therapist is about inspecting a trauma, often in a very raw form, and perhaps for the first time. There is no room for a "public" within therapy. Whereas, the student/teacher relationship, is formed to create art that may or may not stem from trauma, but surely it exists within a post-traumatic timeframe.

Within this public relationship, the teacher must learn how to model ways and means to communicate to help the group interact in significant ways, by effectively using common conversational tools. There are a variety of subtle ways to communicate and build trust with a class. Beyond what we have mentioned already, these skills include *respecting, listening, communicating, word awareness, playing, pausing, online forums, outings* and *sharing.*

Respecting. All components of conversation must be steeped in respect. Respect is inherently subsistent. It revolves around a reciprocity factor, re and pro, back and forth. The adage "You have to give respect to get respect" fits well with the notion of reciprocity. Here are some everyday skills that foster respect:

- Have manners. Say please and thank you to your students.
- Be encouraging. Never shoot down an idea or belittle a student—even if you are "joking."
- Listen.
- Be considerate.
- Do not assume. Regard everyone as an equal regarding ethnicity, income level or gender.
- Be fair.
- Be aware of hidden prejudices. Do not let them control actions.

Listening. There is a difference between hearing and listening. Hearing is a physical ability. Listening is a learned skill. Listening is the presence that emerges from the core of humanness. Listening is a broad term and can expand past hearing what someone is saying to include intuition, the energy of Nature, and the pulse of the group. One can also "listen"

to both verbal and nonverbal forms of information. Listening is not judging, reacting or thinking; it is humbling. Here are a few keys to foster listening skills:

- Maintain eye contact.
- Focus on content, not delivery.
- Try to decipher what the hopes of the speaker are.
- Repeat back a summary of what someone says to you using your own words, "What I hear you say is ..." or "If I understand this right..."
- Insert, "I see..." or "Uh-huh..." to stay active in the process.
- Avoid distractions.
- Practice listening.
- Avoid emotional involvement.
- Don't interrupt.
- Be an active participant.

Also learn how to listen to body language – which is not an all-or-nothing science. Reading body language involves noticing the body's position, the space between things and people, breathing, perspiration, eye movement, facial expressions, and how people touch selves/others. Here are a few tips:

- Eyes looking Right (or up and right) = creating, fabricating, guessing

- Eyes looking Left (or up and left) = recalling facts

- Eyes looking Sideways to the Right = finding sound

- Direct eye contact = honesty (or faked honesty)

- Dilated (larger) pupils = attraction (maybe on drugs)

- Blinking = pressure

- Jiggling Feet = bored, nervous

- Closed Arms = uninviting

- Gripping Upper Arms = insecurity

- Open Legs (male) = arrogance, combative

- Ankle Lock = defensive

- Nail biting = frustration, suppression

- Feet Direction = feet point in direction of interest

Questioning. Teacher-directed questions must also be inspected. The power held within a seemingly innocent question is massive. Questions are the essential component of art engagement. Indeed, art itself is often based on a question.

Questions are powerful because of their ability to both solicit and take away power. For

example, I recall showing a class an image of Gentileschi's "Judith Beheading Holofernes" next to an image of the Caravaggio painting of the same subject. I then asked, "Which of these paintings was likely painted by a female?" At that instant, I felt the manipulative power I had over the class as I provoked a specific answer from the group. I was aware how the way I formed the question evoked a familiar response (to me) and did not invite fresh thoughts (from the students or myself.) Perhaps the better question was, "When looking at art, how important is it to know the gender of the artist?" Such a question leaves room for open-ended discussions, with an answer not entirely known by anyone in the room—including the teacher.

The very act of questioning influences people. It is wise for teachers to question their questions. Here are some things to consider:

- Is this a genuine question? Is it a question to which I don't know the answer? Am I trying to shape a particular answer?
- What "work" do I want this question to do?
- Is the question more likely to evoke a response familiar to the speaker or to invite fresh thinking or feeling?
- Is this question more, or less, likely to enable people to see themselves and others in their social world more complexly than they have?
- Is this question likely to generate hope, imagination and creative action... or is it likely to increase hopelessness and blunted imagination?

Peter London outlines four more key qualities for questioning. In context, his list is meant to help with forming a studio encounter question—something to inspire students to make art about. However, these criteria also provide a good general outline for class discussions:

- Is the question psychologically appropriate? Do teens feel like the question honors their intellect?
- Is it a question that is non-rhetorical? Does the question entail more than a "yes" or "no" answer?
- Is the question self-referential? As much as possible, how can we relate questions to the student? For instance, instead of, "What is in this landscape?" Ask, "How is this landscape like you?"
- Does the question contain age appropriate vocabulary? Please never assume every student in the room has the same vocabulary. (14)

Conversing. There are four levels of communicating. Many people are comfortable with levels one and two: Cliches and Facts. However, meaning-making requires that people learn how to communicate at levels three and four: Beliefs and Emotions. Remember, we don't want to share words, but rather we share messages.

A conversation is a social activity that requires people to co-operate, think about others feelings, and give each other room to talk. It is a reciprocal process that lies at the heart of informal education. Just how we engage in it—the spirit with which we join with others—is

of fundamental importance. We look to be with others, to be open to what they say and to see where the interactions take us. People who become too focused on an outcome or specific talking technique can lose sight of the spirit and style that are central to the process. The leader understands that the words used in conversation are ALWAYS powerful and must make sure:

1. People are taking turns.
2. The language is mindful and spun in a positive way.
3. The information is relevant to the topic.
4. There is some action (smiles, arm movement, gesturing).
5. The experience is being honored.

Margaret Wheatley noticed how transformations often begin with *"It all started when some friends and I were talking..."* (15) She believes most people do not have the courage to begin something new without talking about it with someone else. Talking helps people form affiliations, and at the same time, it lifts the shroud of alienation that comes from a feeling of being silenced. It only takes the courage of one person to begin a conversation, and luckily, it is something everyone both initially knows how to do and, like most things in life, can improve.

Much information would be lost if not contemplated or shared aloud. Groups benefit the most by conversations because they provide a pool of information, perceptions, debates and vantage points. These group points provide students with choices about goals they can make in the future, both artistically and psychologically. True dialogue does not assume that one person (the artist or the teacher) has all the right answers. It does assume that a group can offer an amazing amount of insight and experiences about a topic—more than any one teacher can offer.

Such discussions are best honed under what is called a deconstructive communication style. The language of deconstruction assumes that all people involved in the communications have something to learn (including the teacher) and that there is probable merit to many perspectives. This works especially well when talking about personal art, as the information that comes to the artist is often hidden in symbolism, and the responses it pulls from various people can entice a sudden (and perhaps unintentional) truth for the artist—or audience.

Word Awareness. Semantics makes a difference and can make a room/group feel close or cool. Often creative instruction is dubbed a "lesson." This is a common term used in all of education: lesson plan, daily lesson, lesson learned. The term seems to imply something specific will be learned, and a pre-conceived outcome is known (likely by the authoritarian figure). It further implies learning is not expected to infiltrate beyond the classroom walls. Instead, the creative educator might use the term "experience" (as John Dewey used) or "encounter" (as Peter London uses). Either term sounds a little more enticing than a "lesson" and provokes the possibility of transformation. To have an experience/encounter with something implies openness to something new and even unpredictable that is

informed by intuition. A lesson sounds rigid and presumes an answer is known in advance. There is no mystery in a lesson. To engage students, they must be enticed. Consider which opening line sounds more thrilling:

"Today's lesson is _____."
"Today we will encounter _____."
"Today's experience will be _____."

Likewise, if it isn't apparent, I prefer to call the "class" a "group." "Class" sounds very much like "lesson"—authoritative and dull. "Group" fosters an affiliation—a belonging.

How one addresses a class also matters. A common Midwestern phrase used as a greeting or attention-getter is "you guys." If I have 20 females and three males in an art class yet call, "Hey, guys, I need your attention," then I am excluding 20 people from the class discussion. I realize this phrase is prevalent and most people do not consider this to be exclusive language, but it is. Its acceptance proves sexism is so elusive in society that most people are completely unaware of its influence. Once a conscious decision is made to ditch the term "you guys," practice replacing it with such things as: "Hey geniuses!" or "Can I have my group's attention, please?" or "Artists—listen up!" or "Ya'll!" Here are some other things that a teacher can do to help model the importance of "words" when trying to form a group:

- Use non-sexist language.
- Be aware of classroom communication styles—give all students equal attention.
- Use the term humankind rather mankind.
- Treat students as equals—not as if they represent a gender.
- Discuss sexism in textbooks/visual culture when evident.

Furthermore, groups do not need to foster normative gendered roles. Girls can carry the box of clay just as a boy can curl ribbons. Provide safe places for boys and girls to listen and talk WITH each other. I prefer, "I'd like to talk with you," versus "I'd like to talk to you." Encourage conversations that challenge both the intellect and intuition of both sexes. There is no room for inequality in the classroom.

Good leaders try to be aware of stereotypes and fashion a code of ethics that advocate an unpretentious attitude toward mind and lifestyle that holistically embraces work towards hope, peace, equality, and wellness. No matter how diligently women, peacekeepers and other minorities have worked to be heard, texts and curricula for the arts still promote the male "Masters" of the Western world. Expose students to this fact. Then teach them who the "other" artists are.

Playing. Icebreakers, Surrealist games and activities are a great way to break up the monotony of a class. Icebreakers are also the perfect opportunity to ease people through the discomfort that comes with getting to know strangers. A well-chosen icebreaker game can relax the mood, but a poorly chosen icebreaker can have the opposite effect, making people feel nervous and uncomfortable.

Pausing. I recommend slowing down on the first week of school and playing some icebreaker games to help form group, but it is also important to pause on a daily basis throughout the term. Allow students time to catch up before class begins. Remember, the vision for the "classroom" is to become a "group" and groups like to talk with each other.

When I began teaching, I expected my students to be in their seats when the bell rang. I wanted to get started straight away, but found I was spending time and energy trying to "shush" the class. I gradually learned that it was okay to let things evolve and to start class a few minutes after the bell. It allows students to catch up with each other. I gradually insert myself into these conversations (thus getting the whole group sharing) asking the group, "What are you talking about today?" "What would you like to share with the group?" "Is anyone planning on going to the game?" "It is Jim's birthday? Let's sing Happy Birthday!" Invariably, the conversation gradually flows into whatever the class discussion is for the day—sometimes students don't realize we went from "chatting" to "learning."

Online. It makes sense to utilize online resources to form groups since so many teens communicate using email, MySpace, Twitter, Facebook, Blogger and YouTube, etc. For my courses, I have a Facebook page where I can "friend" my students and post comments and resources/links for them to see. Mostly I post cool art shows or historical finds, and they do too. I keep a separate Facebook page for my real friends and family. However, check with your school regarding an "Internet Conduct Policy." Some public secondary schools are beginning to suggest that teachers should not maintain any social network profiles.

Blog pages can be used in many different ways. Some teachers use blogs as a place to post

information with limited student interaction or use it as a supplement to a textbook or class lecture. For example, "How does the podcast (linked here) compare to the content of your textbook? Same information? Different? If different, how so?" Perhaps a blog platform is used for big assignments, like if a research paper is pending it can serve as a place to post their thesis and allow other students to comment. Another way to use a blog is to require students to post images of independent project work (studio work) online to provide an area for class feedback, or to provide a question/answer space after class.

In my advanced art classes, I keep a Blogger (or WordPress or EduBlog) page for my classes and require bi-weekly homework assignments to be done within that venue. I set the permissions to allow students to post information and comments freely and have discovered the following advantages of online blogs:

- A blog allows students to easily stay in touch when school is cancelled or on recess.
- It allows quiet students to participate.
- It allows students who need more time to think/ponder concepts the time to formulate answers and engage more fully with the online group.
- Important documents like syllabi, rules, and links can be accessed at all times.
- Students can engage on their own time.
- It offers an area to practice reading and writing.
- It allows for the ability to post video, imagery, pod casts and other media.

Before entering into this process, discuss the general guidelines students must use to provide safe and acceptable Internet usage. I also only let members (students of the class) post to the blog—so the online classroom, as it were, is protected from outside lurkers. The downfall? There will be a few students who do not have Internet access at home. It will be important to provide a computer and class time to students who do not have the equipment at home.

Outings. Take students to museums, local shops, day trips and other events to unite the group. If a budget does not accommodate such things, create outings at school by hosting art shows, artist talks or portfolio days. Volunteer to make cards for senior citizens on Thanksgiving or decorate local grocery store paper bags that promote a theme. Consider making the entire classroom into a temporary "new" space -- build a giant blanket fort or other group installation. Perhaps host a fashion show (with photo ops) for the class after creating hair sculptures or designing clothing. Some of these ideas take time and energy to make happen, while others are more spontaneous connections that take nothing but encouragement to occur. Regardless, students appreciate working together, having a "break" from the monotony, finding new ways to connect, and the overall memory of the shared experience. Often these outings are the things students remember the most about their high school days.

Sharing. I am constantly in awe of what students have to offer. Offerings come in the form of helping other students one-on-one or by contributing to a group reflection. These are sometimes subtle and sometimes overt. I see such offerings as little tokens of love, and it is important to both extend and accept love. A teacher can encourage these positive

behaviors by allowing students to care for him/her, too. For example, when a student offers to open my door or wants to share a piece of candy -- I accept the gestures – even if I don't want the candy and/or I can open the door myself. I accept their help because I love them–and I want them to have an opportunity to show love back.

In sharing actions, words, and silence we become better people – every day. To speak further on sharing silence, London taught me a little trick to prompt silence, which involves asking students to "sit still and do nothing" – "nothing more, or nothing less," as he says. (16) By doing this, I am not asking students to pray (though they may) or meditate (though they may) or sleep (though they may) or otherwise partake in anything other than stillness. This stillness is theirs to honor how they wish. Sometimes I ask for stillness after introducing a theme or concept for a studio session to allow ideas to incubate. Other times we do it to form a connection with the group and to still the air before beginning a day. It is welcome before reflection time to help people "hear" art's messages. The stillness might last two minutes or 10 - it depends on the need. Often people squirm at first and don't understand the silence until it "talks" to them. With some prompting, this practice becomes a welcome habit to the group and, eventually, students will ask for the opportunity for stillness.

I have also used "sit still and do nothing" at times of crisis in the school. Unfortunately, it will happen that a staff, faculty or student member of a school system passes away during the school year. When this happens, a teacher is suddenly charged with breaking the sad news and somehow providing a safe place for students to digest the information and mourn. This can be one of the hardest conversations to have, and group silence can be the pause needed to comprehend a crisis situation while making a group feel connected. [See Appendix: Silence.]

TALKING

There are little "tricks" (microscopic actions) a teacher can do to help solicit dialog. For instance, reinforce the notion that when a student answers (or poses) a question, he or she is actually asking it to the class—not just to the teacher. Reading Henry Giroux taught me the skill of "breaking eye contact". Breaking eye contact is a tool to use when a student who is discussing something to the class, is staring the teacher in the eyes (and thus not addressing the class). It is important for the teacher to break eye contact with that student so he/she remembers that the conversation is between everyone in the room – not just between one student and one teacher.

So, when this happens, I have learned to break the contact (that safety net) by walking away, or opening my arms wide to signify the student look around the room. I can also move my head to look around the room to remind the student that they are to speak to each other. I let teens know what I'm up to, and after some weeks of this, students begin to break their habit of authority-dependence (a term I also learned from Giroux). Here are various other "tricks" you can use to provoke group dialogue:

Wait time. Wait time is that long and awkward pause that happens when no one in the group responds to a question.

The reflex of the teacher is to automatically answer his/her own question—but the better option is to wait—for up to ten seconds if possible! If patient enough, someone will eventually answer the question. If not, rephrase the question and/or call on a specific student to answer it.

Three answers. Another trick that prompts conversation is to say, "I need three (or 4 or ?) people to answer this question before we move on ..." The trick is to not give in before moving on. However, if no one is responding, rephrase the question so it makes better sense.

Writing. Do not underestimate the power of taking a moment to have students write down answers and then have them read aloud. Sometimes having the time to think about the answer is all the students need, and pen/paper can incite thoughts.

Prepare. I prepare a list of questions that require more than a yes/no answer to use for leading a group discussion. Such questions might include:
• What is the next question?
• What do we need to know that we do not know?
• Can we compare solutions?
• What stands out the most when you first see it?
• Explain the reason you notice the thing you noticed.
• As you keep looking, what else seems important?
• Why does the thing you mention seem important?
• Imagine being empathetic to this, what do you feel?

Press for Evidence. Ask students to align themselves with resources, theorists, and/or other artists who might back up their statement. Ask about the nature of the evidence provided in imagery or theory. Encourage students to challenge points and openly discuss options.

Move Furniture. Are people sitting in a manner that allows everyone to be seen/heard at the same time? Move furniture to allow for large group or small group conversations to flow easily.

Pause/Blurt. This is good for a review session, or if you have one student who dominates the answer session. Tell students to hold in their answer because you want everyone to have the opportunity to think about it and then count down 3 -2 -1 = BLURT! And the entire class will blurt out the answer.

Form Groupings. Ask students who are sitting next to each other to discuss what they are seeing/feeling about a piece of art or topic. Then have that pair share their thoughts with the pair next to them. Then have these pairs share with the class what they think and why. (Education terms this "pair, square, share.")

Outside. If students are not talking in class, try to strike up conversations with them on a one-on-one basis outside of class, or quietly during class.

Student Facilitators. Have a student begin each class or reflection with a topic for discussion that was picked by you or the student, depending upon the circumstances. Sometimes students are more comfortable speaking to another student than a teacher. The next stage is to encourage (easier said then done) the students to talk to each other outside of

the class.

The One-Minute Game. Go around the room and have each person state what they think about a piece of art for one minute. The person who is next can either continue to talk about the same piece of art, or move on to another piece.

Go-Around. State that persons will speak after the person next to them is finished. This allows people to focus on listening, rather than when to speak. Persons can say "pass" if they do not wish to share.

Questions Only. This can be intense if taken seriously. After contemplating an image, problem, or idea, the people having the conversation can respond only in the form of a question and may not offer other advice or follow-up responses. Allow for quiet/silence in between each question so people can digest information.

Onion. Ask "Why?" five times. (Sort of like peeling an onion).

Class Feedback Form. At the end of a class, provide students with a written opportunity to paraphrase what they learned during that session and to ask any questions. Begin the following class answering their questions. Often if the questions are generated by students, they are more apt to be interested and respond to their inquiries aloud.

Rotating Chair. Format in which students call on each other instead of the teacher calling on them.

Ask. Try not to respond to every student comment; instead ask the class what they think about what has just been said.

Take Notes. Taking notes while students are speaking helps to remember what the students said so that it can be referred to later (in the day or during the year), which also shows them that you value their ideas. This will encourage them to speak in the future. They also feel like they are being listened to and heard.

Be Direct. Do not be afraid to call on students and ask what they think. If they are hesitant or do not want to say anything, let them off the hook. Still, calling out their names can help get discussions going.

The Rules of Reflection.

The ground "rules" for group conversation should be inherent to the group. I find when I give students a bunch of rules to follow (example: Avoid Judgment), they are afraid to talk because they suddenly become afraid of saying something wrong. Instead, I make an overall statement about listening, sharing and respecting the group and then try to model conversation by correcting harshness that might occur and modeling methods both during class and during the reflection. Since the art made at the beginning of a semester will not be risky or deep, it is okay to teach/model reflection practices by trial and error at the beginning of a year. As the art deepens, so will the dialog, and by then, the "rules" will be inherent.

Of course, as the group leader, I have to present some ground rules to facilitate conversation, so here are the general

things I try to model, advocate, and naturally point out during group dialogue:

- Be as open as possible, but honor the right of privacy.
- Information discussed in group should remain confidential. What's said in the classroom stays in the classroom.
- Respect differences and be supportive rather than judgmental. Focus on understanding.
- Give feedback directly and openly about the task and process and not on personalities.
- Encourage shared knowledge, experiences and talents.
- Speak from "I" experience rather than "you," "them," or "we."
- Listen actively—respect others when they are talking.
- Be conscious of body language/nonverbal responses— they can be as disrespectful as words.
- Provide time for "seeing" the work.
- Allow for time to prepare (both students and teachers).

However, before the reflection begins, it is important that we truly honor the "listening" component of the reflection. By this, I mean we must take the time to inspect the art, to sit, look at, be still with it, and hear the art. Interestingly, people tend to judge artwork very quickly (teens and pros alike) and unfairly. Complex ideas take time to sink in, and the art teacher should model reflective practices and discuss the possibility that, as the artist Edward Ruscha promulgated, "Bad art is "Wow! Huh?" and good art is "Huh? Wow!"

A study at the Metropolitan Museum of Art watched 150 people look at six pieces of art and found people spent a median time of 17 seconds with each piece. This viewing time was not related to gender or age, but was strongly related to group size, with larger groups spending more time. In 17 seconds, a viewer might get a sense of "like" or "dislike" (judgment) about the piece, but he/she will not have "heard" or "felt" it in its entirety. (17)

IV. The Times

The future art educator probably is more likely to understand the term "contemporary" vs. "modern" than teachers who have been in the field for twenty years. Contemporary art methods were almost non-existent in high school and/or college campuses until recently. For readers who are not sure about these differences, I need to provide a brief overview.

MODERN
In modern times, an artist became a "painter" or "sculptor" and spent "his" life perfecting one medium while inventing a signature "style" to be given a "one-man-show" in a New York gallery. Artists would paint the same thing over and over, using the same style (think of Jackson Pollock's drip paintings, Jasper Johns's targets, or Hoffman's color fields). Within this system, the general public began to believe art was complex and it required the specialized knowledge of a few experts to understand it or make it. Art critics such as Clement Greenberg emerged to help the public understand art. Critics were the trusted interpreter and judge of the avant-garde. Wrongly, this propagated the notion that art is of "genius," innovation, eccentricity, style and seclusion. Many people still have these ideas about art!

The term "modern" leads people to believe that whatever stems from it are cutting-edge and alive. However, Matisse and Picasso, two "modern" artists who worked in different "styles," are no longer at the cutting edge of contemporary culture. Indeed, while both men were art mavericks in their own right, using paint and color in luscious ways and speaking to the issues of their times, they are not contemporaries, and, dare I say they are largely of little relevance to contemporary teenagers.

Of course, I do not advocate we erase their (or the canon's) contributions to art history, but I surely do not see them as the most inspiring artists for teens. Curriculum designed from modern times often revolves around projects inspired by the elements and principles of design (which is not all that inspiring), the making of pictures in the "style of" dead artists, specialization, and the production of adult-like art. Rarely does modernism focus on meaning-making.

THE CONTEMPORARY
Many of today's contemporary artists are male AND female, as well as "queer," "guerilla," "folk" and more. They do not work in one style or one medium, though they may have a natural aesthetic that emerges with time. "Style" is a modern art characteristic that belongs to critics and historians, not artists—and especially not high schoolers. Remember, teens prefer to make meaning rather produce adult-like products. The goal in high school art is to find voice; not style. ["Reverters" like style, see section: Art Students.]

Contemporary artists are not merely (if at all) interested in singular humanistic expression.

They are more about how experiences made public through intentional art making are/can be responsible to a whole and how they evolve within an eternal contemporaneity (a society that is ever changing and shifting). This means the artists of today are not hermits within their studio painting for 50% of a gallery commission, but rather, they have the option to be collaborators, instigators and mediators, too. They can make art that explores worldwide, social, political, environmental and holistic concerns while considering things such as audience and intent. Nontraditional artists—folk, feminist, visionary—break barriers by making art that is both physically and culturally accessible to more audiences. Contemporary art blurs the line between art and craft.

There are plenty of contemporary artists (artists who are of this time) who talk about the critical issues of today such as sustainability, body image, spirit, and consumption; who use contemporary media such as digital/online art, hypertext, video, sound, and installation; and who make art for public and/or personal reasons. Contemporary teenagers mostly regard these artists as more relevant to their lives than the artists from the Modern era.

Technology and post-modernist ideas have allowed more artists to transcend the tendency to specialize in one medium and to create interdisciplinary work. An "interdisciplinary" artist works in the media that best enables him or her to incarnate their inner vision. An interdisciplinary artist could be labeled a collaborator, printmaker, teacher, ethnographer, designer, catalyst and temporary interventionist all at once. An interdisciplinary classroom contains (or releases) rappers, dancers, performers, ready-made sculptures, paintings, and/or even sound environments.

In other words, the definition of what contemporary art "is" is broad, and unlike in "modern" times, art is no longer neatly categorized as painting/drawing, sculpture and design. Today's art box contains digital arts, performance, ephemeral art, mail art, sustainable art, installation, trading cards, etc.; therefore, the skill-sets needed for art making continue to evolve. The contemporary art teacher must ask: Can movement in space be art? Can art be made with blood, ketchup, bread, urinals, dolls, or golf bags? Can meditation be art? The ephemeral? Given all of these options, how can a traditional technique-based studio art class be and feel relevant to contemporary teenagers?

THE PRIMAL
Art, in the West today, looks and feels nothing like art did 20,000 years ago when "art" began. Art's origins appear to be (if you agree with Ellen Dissanayake) evolutionarily and socially imperative to biological survival. If art is indeed imperative to survival, yet seen today as something to look at, collect, trade, or study -- it is up to the art teacher to build a bridge between the origins of art via meaning-making and the contemporary. As largely taught in American classrooms, art seems absent of what Dissanayake identifies as "making special." Through this idea, she merges art into normal non-aesthetic realms such as play, ceremony and everyday ritual. Finding ritual in things like dinner, festivals, or walks in the woods allows these experiences (when made in the presence of "directive intent") to make people feel special. In turn, life becomes more informed through art. (18) Peter London calls this uniting "Heaven and Earth." Joining Heaven and Earth means to,"... *live in such a manner so as to live here and now as I desire to live there and then.*"(19)

BRAVE ART & TEENS

Primal art deals with the BodySelf. The BodySelf is part of the human that is capable of going to an unknown place and bringing back information. It is the wise part of the human that can either be ignored or utilized for good. It is capable of intuiting, talking back, sending signs, and expressing needs. It is the "hunch" or "feeling" one gets when something is right or wrong. It is often termed the creative spirit, spirit, the divine, psyche, instinct, gut response ... perhaps even faith. Why faith? Because trusting the BodySelf is akin to jumping into the unknown. Regardless of the name, it mysteriously emerges as information and fosters communal dialogue between the Body and the Self. This information solidifies in the form of art.

Paleolithic humans depended on the BodySelf for survival: hunting ritual, communicating with the spirits, and/or as initiation rights. These things are still primal to survival ... and also forms of art. Art as survival? Such a concept is far from most people's idea of what art is today, yet it is still the core of it. Teachers can support BodySelf knowledge by providing students with the opportunity to intimately explore ideas, rather than pre-conceived problems for them to solve. Encourage nuance and voice.

CHANGE
From Primal →to Modern →to Contemporary – art exists in a pattern of change. Within the culture of the Contemporary, it is important to remember that change does not mean progress. Just because movie-makers know how to use more technologically advanced special effects—or more electronics add to music -- it does not mean the films or songs composed from such contemporary tools are better (or worse) than those from the past. Change in a contemporary society often exists as consumerism, not necessity, and this does not equate to progress. If it were otherwise, the denim jeans we wore ten years ago would be fine to wear today; however, the fashion industry would not exist if Madison Avenue did not promote change. Often, what society regards as art is not safe from the arms of consumerism, in fact, it has helped it climb to where it is today. Thomas Kinkade, Andy Warhol, Damien Hirsh and Peter Max are examples of the art/business marriage common in today's society.

Today's curriculum must keep up with the schizoid hypermodernity that is void of the lulls that past eras have provided. For example, between 600 and 1400 in Western Europe, art, music, and fashion changed little during a time of absolute church authority. The Industrial Age launched us out of the Agricultural Age and quickly formed into the Information Age -- and we are now well into the Conceptual Age. My friend Henry Warwick coined this quick shift of events the "Eternal Contemporary." Extended eras of living no longer exist because the contemporary is eternally moving. Aren't these great topics to discuss with high school students?

CONTEMPORARY DIALOG
We live in a post-traumatic century. (20) Student art speaks to it; we just have to be brave enough to listen and help them deal with it. Systematic rape, war, abuse (date/child/drug), gender, injustice, oppression, environmental deregulation, genocide, terrorism, AIDS, etc.

are all parts of recent history and everyday experience at both micro and macro levels. Microscopically, students may be living under physical conditions rife with oppression and abuse within their family and/or a fraction of a societal system (gangs, welfare, unemployment, etc.). Macroscopically, visual culture bombards through television, newsstands, technology, and commercial radio—all manner of information and communications technologies, as well as larger society systems. The art classroom is the ideal place to discuss, debate, share and become aware of similarities and differences that are alive within the group, community and the larger society.

By ignoring "real-life" in the contemporary art classroom, opportunities for growth, empathy and awareness are lost. This book advocates the process of SHARING student work to be the most vital component of an art class. The after-effect of the creative making process is eventful enough to cause paradigm shifts in a student lives. Without dialog, reflection, contemplation, sharing, interpreting and revealing what the "art" solicited/s, people do not get the opportunity to learn.

Analyzing this contemporary traumatic era through art does not imply that one subscribes to the general pessimistic/lethargic fear factor that seems in place within Western culture. On the contrary, this subscription brings new paths for hope. It becomes an interesting, laudable concept for the art classroom including critical inspection of why and what a post-traumatic century is, how it occurred, where it is going, how it can inform, and what role art plays (or can play) in healing.

Art making and sharing can help students understand their own transformation is social, political, and culturally whole. Eventually, even if the student hasn't had a perceived direct exposure to trauma, there are certainly indirect events of which she/he is a part. Students who listen to other teens or contemporary artists think about how they are connected to these times. In correspondence with interdisciplinary artist Dread Scott, he noted:

> *Issues of race as addressed by artists of color are very*
> *relevant for white people. Just like it is important for men to*
> *view art by women that addresses the oppression of women.*
> *Queer issues are not just for the lesbian and gay community...*
> *The issue is not principally what is your lived experience,*
> *but rather what world do you want to live in?* (21)

THE CONTEMPORARY ART STUDIO
So what does the contemporary high school art room/artist studio look and feel like?

Sure, these rooms will still be stocked with paint, charcoal, paper and clay. However, students will also use the Internet, their visual culture, digital apparatuses, ritual, meditation, performance (and more!) to engage with their world through art. They will find meaning via things the art teacher may not know how to do!

Invariably, the teacher will learn new things based on student needs, culture and geography – while teaching her students a thing or two. For example, my students in

Kentland, Indiana, had very different interests and needs from my inner-city Benton Harbor, Michigan students. My Benton Harbor students knew to dive under the desks at the clank of anything loud (this was during the heyday of drive-by shootings). My Kentland kids knew the difference between a combine and a tractor (and the aromatic difference between chicken and cow manures). With each group, I could have chosen to teach a curriculum based on traditional techniques and historical art, but I would have failed them and the arts. A few students from each group would surely excel, but most of them would have left the class thinking that art was irrelevant to their lives. I had to take the time to get to know the local culture of the group and ask students what their interests and curiosities were in order to engage these students, be it via traditional lore, music, low-riders (a customized auto), or whatever it took. After all, how is the ability to make a pencil drawing of an apple going to benefit (or interest) a 14-year-old teenager who is pregnant and hungry?

"... the making of aesthetic experience,
the making of meaning,
the making of social change,
the making of progressive sites of teaching and learning, and
the making of justice
need not be fragmented
or disjointed activities.
They can be the same thing."

~ Pete Hocking

V. The Knowing

Art teachers often contend with how the culture of the student has framed his or her idea about what knowledge "is" – which equates to a specific idea about what art "is." Often, their initial mental conception about art may be at a low-level ability, because, let's face it, the general public can think some pretty insular things about art. The good news is, with consistent dialog and awareness, a student <u>can</u> eventually learn to grow in his/her path of knowing.

The "can" part is a critical part of a teacher's vision. It is an end goal – something far away – a goal to slowly move toward. What is so wonderful about the word "can" is the scope of the possibility it encourages. Once a student realizes they "can" draw outside the lines, use non-traditional media, air hidden voices and/or seeks alternatives -- their whole world expands.

STAGES OF KNOWING: Academics

This awareness of knowing and can-be are incremental and is well documented. Humans go through stages of knowing, and if a teacher is aware of where his/her students are at a given time, he/she can better empathize and guide students further along.

The work of William Perry outlines the epistemological development of a student's conception of his/her own nature and origin of knowing. The following is a summary of the "positions" Perry outlines in this progression. (22) I've included examples of "thoughts" students have about art as they progress through these positions. The art teacher will hear these same thoughts repeated over and over throughout the years. Such statements provide a decent base for responding to the opinions—and knowing where the person developmentally is when it comes to understanding the larger concepts. (Readers may also want to consider Efland's book <u>Art and Cognition</u>, or <u>Women's Ways of Knowing</u> by Belenkey et al for more ideas.) The positions are:

1. **Basic Dualism:** (Early childhood to adolescence to early college) Passive learners who depend on authorities to hand down truths and often see things in black and white/good and bad. These students "receive" knowledge and are often intolerant of ambiguity. It is frustrating for them to interpret a painting or a poem when there is no "right" answer, and are uncomfortable with independence. They expect teachers to give them the answers. Students at this level might say things like: "That's not art!" "A three year old can do THAT!" "Is this how you want it?" They will be afraid to risk, to make a mistake, or to make anything unrealistic.

2. **Multiplicity:** (Adolescence to early college) Learners come to understand that authorities might not always have the right answers, especially in the realm of the arts, where information can be subjective. Once this fact gels, students begin forming their own opinions, but are uncertain because all opinions seem valid, and therefore fail to commit to knowledge. Students may say something like: "I might not know much about art, but I know what I like." This newfound confidence does not mean that the student will embrace the path towards Relativism. They may just drop out because they are still afraid of uncertainty.

3. **Relativism Subordinate:** When people reach this level, they perceive that all knowledge is relative, and that they need to orient themselves based on evidence. Students see information as relative, and understand that what is true in one situation may not be in another. They want the teacher to help them compare alternatives. For example: "Though not my aesthetic preference, I feel calm because of the hovering pillow-like cloud form."

4. **Relativism:** Students completely understand that the truth is relative to the context in which it occurs and on the framework the knower uses to understand the event. For example: "Within the context of the area, Serra's work creates its own space and place. I can see why his public art could be considered controversial." Like math and science, art has its own "vocabulary." As Perry mentions, the content-based vocabulary become more specific, relevant and profound as the learners grow.

5. **Commitment/Constructed Knowledge:** Student becomes committed to taking positions. Knowledge becomes known as constructed not given; contextual not absolute; mutable not fixed. Students are aware of their own thoughts, judgments and prejudices and try to integrate knowledge that is felt intuitively with knowledge they had learned from others. Students see teachers as mentors who support learning.

It is only within the realm of relativism that Perry believes personal identity can be affirmed. It behooves the art teacher to be aware of this educational transformation process and know that the majority of students who enter the classroom will be at the Basic Dualism stage. Plenty of practice and time will need to be devoted to easing the safe and rigid thinking of these students. Further, it is worth highlighting the fact that there is a big risk of losing students well into the last stage of knowledge if things become too "loose" or unbalanced for the learner.

To bring the idea of knowledge development into a realm specifically devoted to the understanding of art, in the 1970s, Abigail Housen's research demonstrated that viewers understand works of art in predictable patterns called stages. These stages are integral to learning and can be progressed through using Visual Thinking Strategies (VTS). VTS

involves a simple protocol that prods students to look, think, reflect, defend and share ideas about art. The more students are asked to "read" art, the more they grow in their visual literacy. The www.vtshome.org website outlines the stages as follows. Most teens are at Stages 1 and 2.

Stage 1. Accountive. These viewers are storytellers. Using their senses, memories, and personal associations, they make concrete observations about a work of art that are woven into a narrative. Here, judgments are based on what is known and what is liked. Emotions color viewers' comments. The viewer and story (image) are one.

Stage 2. Constructive. Constructive viewers set about building a framework for looking at works of art, using the most logical and accessible tools: their own perceptions, their knowledge of the natural world, and the values of their social, moral and conventional world. If the work does not look the way it is supposed to, if craft, skill, technique, hard work, utility, and function are not evident, or if the subject seems inappropriate, then these viewers judge the work to be weird, lacking, or of no value. The viewer looks carefully and puzzles. An interest in the artist's intentions begins to develop.

Stage 3. Classifying. Classifying viewers adopt the analytical and critical stance of the art historian. They want to identify the work as to place, school, style, time and provenance. They decode the work using their library of facts that they are ready and eager to expand. This viewer believes that properly categorized, the work of art's meaning and message can be explained and rationalized.

Stage 4. Interpretive. Interpretive viewers seek a personal encounter with a work of art. Exploring the work, letting its meaning slowly unfold, they appreciate subtleties of line and shape and color. Now critical skills are put in the service of feelings and intuitions as these viewers let underlying meanings of the work and what it symbolizes emerge. Each new encounter with a work of art presents a chance for new comparisons, insights, and experiences. Knowing that the work of art's identity and value are subject to reinterpretation, these viewers see their own processes are subject to change.

Stage 5. Re-creative. Viewers, having a long history of viewing and reflecting about works of art, now "willingly suspend disbelief" and allow their trained eye, critical stance, and responsive attitude to be their lenses; as the multifaceted experience of the artwork guides the viewing. A familiar painting is like an old friend, known intimately yet full of surprise, deserving attention on a daily level, but also existing on a more elevated plane. A work of art is like a familiar friend to the viewer. http://www.vtshome.org/pages/art-aesthetic-development 2/3/11

STAGES OF KNOWING: Self

If human intelligence is varied, and people experience knowledge and intellect in positions/stages, then it seems appropriate to touch upon how humans process what it means to be human – to talk a little about the *personal* side of knowing. Psychotherapist Carl Rogers was interested in the development of a self-concept and

progress from an undifferentiated self to being fully differentiated. He stated that people exposed to unconditional positive regard (basic acceptance and support of a person regardless of what the person says or does) were more likely to become fully-functioning. In his 1961 essay, "The Good Life," he outlined a fully-functioning person as having:

1. A growing openness to experience.
2. An increasingly existential lifestyle.
3. Increasing organismic trust.
4. Freedom of choice.
5. Freedom to be creative.
6. Constructiveness and reliability.
7. A rich full life.

Importantly, in the 1950s, he noticed that his patients were able to change some of their initial problems when exposed to therapy and new ideas. Note the basics of therapy are dialog and sharing – just like meaning-making in the art classroom is. Furthermore, Rogers linked human transformation to education and documented nine outcomes as a result of exposure to education (which can be likened to therapy per se):

1. Accepts self and feelings more fully.
2. Becomes more self-reliant and self-directing.
3. Becomes more flexible, less rigid.
4. Adopts more realistic goals for self.
5. Behaves more maturely.
6. Changes maladjusted behaviors.
7. Becoming accepting of others.
8. Becomes more open to what is going on inside of self.
9. Changes basic personality in constructive ways. (23)

Psychologists have documented needs and goals of humans applicable to their age. Erik Erikson presented the Eight Stages of Development in 1956, and Pam Levin presented her own Cycles of Development in the late 1970s. Their overall premises are similar and believe that humans spend a lifetime transforming within a series of stages that extend from birth to death.

Erik Erikson. Erikson felt that each person's development is based on mind, body and cultural circumstance; and that certain goals and behaviors can be expected within each of these stages. Since this book focuses on teens, I am skipping to Erikson's "Stage 5: Adolescence 12 - 18". This stage cites the ego development of this age to be about Identity vs. Role Confusion and considers the basic strengths of a teen to be that of Devotion and Fidelity.

> Up to this stage, according to Erikson, development mostly depends
> upon what is done to us. From here on out, development depends

primarily upon what we do. And while adolescence is a stage at which we are neither a child nor an adult, life is definitely getting more complex as we attempt to find our own identity, struggle with social interactions and grapple with moral issues.

Our task is to discover who we are as individuals separate from our family of origin and as members of a wider society. Unfortunately for those around us, in this process many of us go into a period of withdrawing from responsibilities, which Erikson called a "moratorium." And if we are unsuccessful in navigating this stage, we will experience role confusion and upheaval.

A significant task for us is to establish a philosophy of life and in this process we tend to think in terms of ideals, which are conflict free, rather than reality, which is not. The problem is that we don't have much experience and find it easy to substitute ideals for experience. However, we can also develop strong devotion to friends and causes. It is no surprise that our most significant relationships are with peer groups.
(http://www.learningplaceonline.com/stages/organize/Erikson.htm 2/4/11)

Pamela Levin. In the 1970s, has also documented a series of human development stages. She considers adolescence to be from ages 12 – 19, and calls this time frame "Stage 6: Integration and Regeneration."

The tasks of this stage focus on identity, separation, sexuality and increased competence. Levin argues preoccupation with sex and people as sexual beings is a hallmark of this stage. Adolescents may have turbulent body changes and energy levels, with higher needs for sleep. Drugs, sex and music are topics of interest; philosophical questions and social issues may become more important. Teens worry about their identity, sexuality, appearance and their future. During the years 15 through 17, they recycle the stage of power and identity. This typically shows up in "why" and "how come" questions as they incorporate new identities and relationships, and learn to solve complex problems. Starting at about age 16 and extending through 19, teens recycle structure. Short periods of testing or breaking rules are typical behaviors.

In Stage 6 the task is to decide that it is okay to be a sexual person, it's okay to have a place among grownups, and it's okay to succeed. Main questions to be addressed: How can I become a separate person with my own values and still be okay? Is it okay for me to be independent, to honor my sexuality and to be responsible? She states that the developmental tasks of the adolescent are:

- To take more steps toward independence.
- To achieve a clearer emotional separation from family.
- To emerge gradually as a separate, independent person with one's own identity and values.

- To be competent and responsible for one's own needs, feelings and behaviors.
- To integrate sexuality into the earlier developmental tasks.

http://umaine.edu/publications/4427e/ 2/3/2010

Overall, it is important for teachers to be aware that they are a part of the overall human development process of a teenager (along with heredity, parents, other adults and peers). If we understand how the emotions and struggles of a teen are somewhat predictable, then we can help them try to find their place in the world. Adults can be of help teens when they:

- Continue to offer appropriate support.
- Accept learner's feelings.
- Confront unacceptable behavior.
- Be clear about school's position on drugs etc.
- Encourage growing independence.
- Expect thinking, problem-solving and self-determination.
- Confront destructive or self-defeating behavior.
- Celebrate emerging adulthood, personal identity etc.
- Negotiate rules and responsibilities.

Adults can harm growth when they send the message: Don't grow up. Given such information, doesn't an art class that values sharing and making-meaning seem like the perfect antidote for a teen struggling to develop?

I cannot help but marvel at the similarities between Perry, Rogers, Erikson, Levin and general creativity! People who are exposed to new ideas and broad possibilities rarely step outside of their comfort zones. Hence, they rarely experience transformation. The art room is the PERFECT place for such significant activity.

QUOTIENTS
What are the "intelligences" that art class can address?

> In the heyday of the psychometric and behaviorist eras, it was generally believed that intelligence was a single entity that was inherited; and that human beings - initially a blank slate - could be trained to learn anything, provided that it was presented in an appropriate way. Now an increasing number of researchers believe precisely the opposite; that there exists a multitude of intelligences, quite independent of each other; that each intelligence has its own strengths and constraints; that the mind is far from unencumbered at birth. (24)

Howard Gardner outlined seven forms of intelligences (collectively called Multiple Intelligences). They include *linguistic, logical, musical, kinesthetic, spatial, interpersonal,* and *intrapersonal*. These intelligences, according to him, are amoral - they can be put to constructive or destructive use, and can be honed to create a world in which a great variety of people will want to live. Why do I mention these here? Mainly because it is important to be hyper-aware of the fact that many students in art class might have "other"

skills to exploit in order to help them find "their" meaning. The kinesthetic or linguistic learner might excel at contemporary performance art; the musical learner will likely enjoy the work of Laurie Anderson; the logical student may thrive using design-based works.

Also note that other scholars support variables within Gardner's intelligences:

IQ - Mental intelligence: being able to solve complex problems or remember facts.

EQ - Emotional Intelligence: recognizing, understanding, and choosing how to think, feel, and act.

PQ - Physical Intelligence: developing overall physical fitness, balance, agility and coordination.

EX-Q - Existential Intelligence: concern/awareness of ultimate issues.

SQ - Spiritual Intelligence: having an awareness of the world and your place within it.

ECO-Q - Ecological Intelligence: knowing the hidden impacts of what we buy can change everything.

NQ - Naturalist Intelligence: enables human beings to recognize, categorize and draw upon certain features of the environment

I'd like to emphasize the idea of Emotional Quotient (EQ). The premise of EQ is that success requires effective awareness, control and management of one's own emotions. EQ is the development of compassion and humanity. People with strong EQ have less emotional 'baggage', and conversely people with low EQ tend to have personal unresolved issues which either act as triggers or are constants in personality make-up. Goleman identified the five 'domains' of EQ as: knowing and managing emotions; motivating self; recognizing and understanding other people's emotions; managing relationships. Notably, Goleman claims that if the IQ scoring has to play any role in success, it can't be more than 20%. He also claims that 80% of success in life is based on emotional intelligence. (25)

SENSING
Another form of knowing is sensing.

I often call out over my students, "Trust your hand, not your head," as they begin creations in class. This statement scares many students who are more accustomed to doing what the head considers being the "right" thing rather than exploring where the hand might creatively meander off to. The art teacher needs to understand students are accustomed to thinking, and that over-thinking can easily trump creative freshness because thinking is a skill-set that is more well honed and is, therefore, more natural to people. "Thinking" is safer and requires less risk than venturing into unknown creative spaces. Therefore, it can be difficult for students (and teachers) to journey into the unknown.

The creative unknown is that intuitive dialog between the Body and the Self. I dub this information as "BodySelf." Art teachers (and artists) understand the entire body has intelligence and realizes the benefits of sharing this wealth of knowledge with students. Why is such exposure important to teenage artists, and what exactly IS the language of the BodySelf?

Language of the BodySelf emerges differently in all people. Sometimes it comes in the form of a dream or a voice; or it will emerge in life on a paper or canvas in the form of a symbol or metaphor. Some people can "hear" or "see" the BodySelf instantly, while others have to learn how to find it.

The art teacher who is open to the idea that art can be a pathway to inner knowledge honors primordial survival. As we mentioned in an earlier chapter, since the time of late Paleolithic European cave drawings art has been an integral part of spiritual expression, evoking the deepest human passions and emotions, as well as connections to other dimensions. Spiritual arts are ripe with symbols, imagery, and ways to depict and find truths. It is within this intuitive BodySelf space that truth, uniqueness and creativity emerge from the BodySelf via *sensing, intuition*, and various *ways of "seeing."*

Sensing. The senses see, hear, touch, taste, and smell. The senses extract details in magnificent ways and see vivid colors, feel textures and embrace the fragrance of objects. People who are intimately aware of such details are Sensors. Sensors pay attention to the light, shadows and context of "things" in the "now." For example, when a Sensor looks at a yellow flower he/she will describe the five golden petals that gently fold from a central disc of umber bristles. She will note its country cottage fragrance, and find pleasure in the tainted shadows that dance onto the cerulean-tinted plastered wall behind it. Such sensory details help with observation skills, the enjoyment of aesthetic moments, and an awareness of the "moment."

Intuition. A honed intuition is the sixth sense of the Sensor. In philosophy, intuition is the power of obtaining knowledge that cannot be acquired by reason—or even experience—but is rather an indescribable sense about someone or something. It takes information and forms it into what can be. Intuition is not something that people acquire; it is already a part of the mental and emotional framework of humanness however, it is something one can develop as it is always working and producing information.

A person with a strong sense of intuition is called an intuitive. Intuitives, as artists, tend to look for underlying meanings, implications, and connections to sensory information through symbols that can emerge in an art form and usually does not speak in a clear language. The goal of the intuitive is to bring non-conscious data to the mind/form and learn from it. For example, when an intuitive sees a flower he/she will describe how it reminds him of a September day at grandma's house and may recall a lesson or message from that time. Perhaps that flower emerges as a spirit guide or omen to the artist. The attention will not be on the flower (like it is with the Sensor) but on the connection one has to it and the message that stems from it.

Artists are generally a combination of sensors and intuitives. Some people tend to lean more in one direction than the other. Either way, the BodySelf becomes an inner guide that unlocks the wisdom via both the senses (the details/micro) and the non/subconscious mind/intuition (the big picture/macro). As time is spent developing trust between the Body and Self, the language/meaning becomes easier to interpret. Indeed, intuition can connect the artist to a greater source of knowledge. In turn, art can be a tool for human development.

Seeing. The typical "seeing" used in the context of art education aids the Sensor's observational technique by helping them look closely at something in order to scan, think spatially, and to notice lines, shapes, colors, and textures. However, this basic—though heightened—form of seeing can eventually morph into other visual aspects of knowing, which can also help foster "art selves."

Other types of "seeing" are byproducts of the Sensor and Intuitive and can be referred to as: *aesthetic moments, awakeness, experience, visuality*, and *indigenous* as described here:

> *Aesthetic Moments.* An aesthetic (a philosophy of beauty) moment is the sensation, joy, and/or calm a person gets from mindfully appreciating the simple and free things around them like the shapes in the clouds, the colors in the dishwashing bubbles, the yellow-green of a single pine needle that gently spikes upwards, or the creamer swirling in the blackness of a morning coffee. Such awareness leads to an appreciation of the "moment."

> *Awakeness.* Aesthetic moments can lead to a deep awareness of being "awake" or alert. In Eastern terms, seeing is nothing more or less than perceiving things in their state of "suchness" rather than as one may wish, or believe, them to be, whereas, the Western way of seeing relies on the existence of form. In other words, seeing form is illusory. Zen Buddhists see that all things arise together. For some people, art can become a form of meditation and knowledge, a way to be awake to the world.

> *Experience.* Dewey's idea of experience as it relates to seeing involves a human connection between Self and Nature. Such seeing/awareness cannot be learned through concepts or observations; it can only be learned by experience. Dewey does not separate interaction from "seeing" but rather unites ideas with actions in order to form a lived experience, and, therefore, art that is ripe with life and not someone else's ideas or experiences. Further, Dewey outlines the difference between "experience" and having "an experience." The latter is the goal:

>> *Oftentimes, however, the experience had is inchoate... Things are experienced but not in such a way that they are composed into an experience... having AN experience... runs its course to fulfillment. Then and only then is it integrated within and demarcated in the general stream of experience from other experiences.* (26)

Visuality. Visual culture is a byproduct of the eternal contemporary age and bombards students every day through television, newspapers, billboards, video games, Facebook ads, cereal boxes, magazines, etc. The visuality movement is a critical inspection of the material world to be bridged with the student world, especially since marketing to children is pervasive. Teens must be able to think critically and maintain awareness toward sign systems to make choices in society.

Let me tell you about Alicia. Alicia turned in a sketchbook assignment where students were charged with depicting the word "see." Alicia cleverly cut out magazine words, labels, TV Guide info, and lyrics to compose on a page. Such images included a testosterone-powered male that must have been a famous pro-wrestler, ads for clothes like "Wear it now!" or "Stretch Seersucker Short," and lyrics to a "Teenage Dirtbag" song. This collaged imagery made me realize how different my visual culture was from hers, and, because I chose to not have a TV in my home, to only listen to public radio, and otherwise stick to non-fiction, my elitism was doing a disservice to my teenage students. How could I help Alicia sift through these texts/images if I wasn't aware of them on some level too? If communication involves an overlapping of intelligence, and if I cannot form cognizance with my students, then we cannot communicate. (I bought a TV.) Often imagery that comes to us via information and communication technologies is ripe for discussions about gender identity, stereotypes, "gaze" issues, and other underlying values embodied in media.

Indigenous. The term "seeing" has been broadened by indigenous cultures for centuries. The various forms of seeing do not surprise many cultures. Some cultures enthusiastically recognize four ways of seeing: external seeing (perception), internal viewing (insight), holistic seeing (vision), all surrounded by the fourth way of knowing (intuition). Likewise, there is openness of directions – expanding past the East, South, West, North – to include Above, Below and Within. For many cultures, art is something than cannot be defined as a compartmentalized aesthetic, like the majority of Europeans define it. Rather, art can become "WOLAKOTA"—which means "art, music, philosophy, aesthetics"— a way of life. Likewise, no separation of art and culture exists in Australian indigenous cultures or many other cultures around the globe that have no independent word for "art." Globally, art is not considered to be separate from life – much like it was with our primal ancestors.

Art, through these various forms of "seeing," becomes a form of intuition that emerges from the BodySelf. This does not happen overnight—it takes carefully planned vision from a passionate leader who understands that a careful planting of stepping-stones helps technical, physiological, and psychological growth to coalesce.

Student awareness of BodySelf capabilities and knowledge expansion can be honed in an art class most effectively when the teacher has undergone his/her own development of

knowing and sensing too. In such a case, ONLY the maker can provide the voice/intuitive symbols of the experience. That which emerges intuitively is unknown to anyone else in the room—including the teacher.

Brave Art in Action:
I am.

The most valuable teaching skill I learned while watching an experienced art teacher was ... calm ... and I now try to incorporate this in my own teaching as much as possible. Adolescents live in a hectic world. Their world is fast, in your face, aggressive, competitive and there is no time to let out a breath and encourage students to develop awareness of metacognition – unless you t/make it. Teachers need to provide opportunities for "voice," whether it is a voice in artistic expression or a voice in verbalizing impressions and thoughts about art work or, even just general thoughts about their world. Regardless of the age of the student, it has been my experience that they crave that opportunity to "tell" about their art work. Providing opportunities for voice takes away the fear of personal expression, fear of judgment, fear that "I" have nothing to offer, and it offers teens a way to connect with a group (which is at the forefront of their minds at this age).

I tell my students we are all artists at different stages. As we learn about our Selves, we add more skills to our "artist toolbox," and as our toolbox fills, so does our insight about our world. Yes, as art teachers we have to provide skilled instruction on technique, mediums and art knowledge; but I have learned that it is more important for teens to be given the time ... the calm ... to discover their "Self." Even I, the teacher, had to learn to be brave enough to let this happen ... and I now consider myself to be a middle-aged and "brave" artist and teacher ... and I'm proud of it!

- Susan Pack

VI. Creating

What, exactly is creativity? Linda Z. Smith, co-founder of the Creative Spirit Center in Midland, MI (now called Creative 360), provides me with my favorite definition of it. Linda says, "Creativity is: "*YES!*" However, most people are uncomfortable with such a whimsical definition. Because both art and creativity are difficult to define, and people know just enough about it to realize there may or may not be a "right" definition, the topic is often scary to broach. Likely, if a group of adults are asked to define creativity, they will say "personal expression." On one level, this is true, but creativity can be so much more.

LEVELS of CREATIVITY:

EMERGENT

INNOVATIVE

INVENTIVE

TECHNICAL

EXPRESSIVE

Irving A. Taylor (a psychologist who studied creativity and creative processes) arranged creativity levels into a creativity hierarchy that recognizes five levels:

Emergent Creativity. Emergent creativity is the highest creative level. It involves rejecting current laws forming completely new theories about how the world works. This often results in a ground-breaking ideas. Few people achieve this level.

Innovative Creativity. Innovative creativity involves departing from existing thinking patterns and making the leap to "out of the box" thinking. Results in something that seemingly has not been done before.

Inventive Creativity. In this stage, we develop the ability to creatively combine existing technical concepts using prior design solutions to create new designs. Examples might be to use an old item in a new way.

Technical Creativity. Here we use rules and physical laws to constrain our thinking, with little expressive spontaneity. Think of this stage as "practicing." Things that emerge may be new to you, but may already be known to the world.

Expressive Creativity. These are unfettered ideas, generally primitive, that emerge without the benefit of any guidelines, physical laws, or other restrictions. You might think of expressive creativity as the child given a box of crayons to express him/herself.

Many classes (including art) give students a problem to solve rather than a problem to find. It is the discovery and formulation of ideas/art that is the call to creativity. Creativity is a skill that is uniquely human as many machines can solve problems. Framing "creativity" as problem-finding may help students who would rather think of themselves as intellectuals to partake in creativity. The "scientist" in class must be made to feel that what he/she offers is valid (and it is) and should be reminded that being creative requires both logic and creativity on some level. This is most evident at the innovative and emergent levels.

THE CREATIVE PROCESS

All work has a beginning, middle, and end . . . a process to go through. Something compels the artist enough to want to start creating, to put up with the unfinished (often ugly) work, and then to further grapple with the possibilities and developments along the way. In 1926, Graham Wallas constructed a model of the creative process that included four phases. These phases have been expanded on by many people throughout the years, but the original core ideas remain: *Preparation, Incubation, Illumination*, and *Verification*. Just like an art teacher must understand the physical and developmental progression/process of a human cognition, it is helpful to also understand the process of creativity. The creative process generally follows these stages:

Preparation. Discovery of the subject or problem is defined and researched. The right brain begins thinking of imagery and sets groundwork and goal. Perhaps there will be time to research about the subject, look at imagery, read, or otherwise saturate the Self in dialogue about the subject. This can feel more like work than

play. *(Classroom application: This might be the time that the teacher is inspiring students by providing facts about a topic, showing them images of art, providing readings, or having a class discussion with the goal of inspiring the artist to extract a subject or solve (or find) a problem that will result in an artistic creation. This phase could also include group brainstorming or practice sessions that generate a plethora of possibilities. The art student must fully accept the situation to be inspired enough to begin generating art response options. At this point, no one should be evaluating - just generating.)*

Incubation. A period of gestation and maturation of ideas that takes place at the subconscious level. At this point, the artist/student is developing a response to the subject. They may have a mental image of what they want to create, but this changes as they get deeper into the imagery. *(Classroom application: Students continue to generate response options to the subject by looking over, scribbling about, sketching, continuing to research, writing, clarifying, and formulating preparation information to select and choose among options. It is difficult to assess how students are caressing the subject and the teacher can only hope that the student is thinking about/meditating upon the possibilities throughout their day. For some people, they may already be working on the "piece" though unaware of exactly what will form.)*

Illumination. The "Eureka!" factor. The idea explodes into our conscious when we least expect it. It is the sudden appearance of a solution or focus. The work is not complete yet, but the creator feels he/she is on the right path. This can be joyful. *(Classroom application: This moment might come as a dream, vision or "Aha!" moment during a conversation or reflective moment. It can come while the work is in process, or it might be the catalyst to beginning the work, whatever form it takes, it is a release to a simmering problem and often feels invigorating. Something about an "Aha!" moment feels right and true, though its meaning may not be entirely known at this point. This does not mean that the entire piece is realized, but maybe a significant and specific symbol, color or overall patterning emerges in the brain or on the art. Once students are here, they become fully engaged in the creative moment and are probably working quietly.)*

Verification. A logical left brain process that focuses on ideas and checks the final conclusion. *(Classroom application: This is the final product stage. The student artist will decide if the pieces all fell together how he/she intended, or if some final touches or an entire re-do is needed.)*

Though the creative process is an individual one, the fact that there is a documented "process" helps demystify what it means to "create." Sharing these steps with students who might be otherwise afraid to enter into the process will help ease their trepidation. The first two steps are the hardest steps if the artist is not sufficiently inspired to proceed. If seemingly stuck, encourage students to work together or otherwise amass enough information to proceed and brainstorm ideas.

Secondary art teachers often force students to plan out their pieces by asking students to make six sketches, mind-map, storyboard, or bring in photo references to help them compose their art. Of course, some students will appreciate the prompting, but others are able to "incubate" ideas in a way that is personal and relevant to the person's process. In other words, some people like to "plan" out their art, and some like to "discover" it. The teacher's mandate to have all students fully compose their art before beginning to make a product can rob students of a true creative experience. Planning allows the logical side of the brain to hamper what the intuitive side might otherwise be trying to say. Instead of imposing criteria, the art teacher can offer opportunities for shared dialogue, teacher-led inspirations, practice (an often overlooked part of creativity), shared brainstorming and BodySelf silence.

Ask your artist friends about their approach in the studio to get a general understanding about the breadth of possibilities. My friends rarely admit to being exactly alike in their process. One friend just "goes" and rarely fusses with whatever comes out in the end. Another one states she works in drafts, slowly composing and altering as she creates. I also know some artists who rely on fixed rules of composing associated with a known beginning and an ending (like always completing the background, then middle-ground, then foreground). Since teens are new to the creative process, the teacher can offer choices and ideas about these choices rather than set demands. With time, students will come to learn what works for them.

This means the teacher must release control of the end product and allow student experiences (the creative process) to unfold naturally. This does not mean the teacher is fostering a chaotic or nonchalant classroom. In fact, creativity is not harbored in chaos. Meaning merges when housed in an environment of respect. Dr. Emma Gillespie outlines three major components of creative instruction:

1. CHOICE: Student choice of materials and art production.
2. VOICE: Student art works are the result of individual solutions to the experience.
3. CHALLENGE: The experience requires the individual solutions with an application of learning objectives. (27)

THE "ZONE"

It is also good for the art teacher to know, that somewhere between steps 1 and 3 of the creative process mentioned above, silence becomes an important classroom tactic to help this creative process run its course. Betty Edwards, the author of Drawing on the Right-Side of the Brain tells us that talking during art making takes away from the brain's ability to "look" and create art. She says that talking is a form of naming, and naming is logic (a left-brain task). Since logic is better well honed in school it can trump "creating" (a right-brain task). But silence helps with creative processing and put people in "the zone."

The zone makes time go away and imagery appear. It is a healthy benefit of art. Martin Buber talks about this in I-Thou when he describes it as a state of grace (in his case, when he is in dialogue with God, but he equates making art and divinity as the same thing). He calls it a state of "unlimitness." Mark Doty describes the zone in his book Art of

Description as, *"... self-forgetful concentration,"* that is, *"precisely what happens in the artistic process—an absorption into the moment, a pouring of the self into the now ... That is what artistic work and child's play have in common; both, at their fullest, are experiences of being lost in the present, entirely occupied."*

I like having scientific theory (pseudo or not) to back up any request I might have for asking students to work quietly. I remind students their brain cannot access its art side if the talking side of the brain is being used. [Side note: if the class has a hard time getting started on something, I will say, "Please give me 15 minutes of total silence," knowing that the 15 minutes will turn to 40 without my prompting because students will slowly get in the "zone."]

Academics sometimes dispute right brain vs. left brain theories, but neuroscience is quickly catching up to esoteric thoughts that have been around for thousands of years. For instance, the ancient Chinese philosophy of Yin/Yang observes all things have contrary forces (sun/moon, happy/sad). These forces interconnect and are interdependent in the natural world and give rise to each other in turn. The brain is made up of similar dynamics and balances. Artists need to utilize whole-brain forces in order to hone their craft and access "the zone." In this realm, the right brain houses intuitive capabilities and the left brain deciphers the world more logically and literally. Betty Edwards (author of "Drawing on the Right Side of the Brain") established a worthwhile career teaching artists how to "see" using right brain/left brain ideas. However, it was Roger Sperry who, in 1981, won the Nobel Peace Prize in Physiology or Medicine for his discoveries in the 1960s concerning differences in hemispheres while studying epilepsy.

Left Brain (L) = Logic (Yang/East)	Right Brain (R) = (Yin/West)	
White	Black	
Facts/rules	Imagination	
Past	Future	THE ZONE
Knows names	Knows functions	
Math/science	Philosophy/religion	
Time-conscious	Impetuous	
Words	Visualization	
Linear	Intuition	

SUPPORTING CREATIVITY

The leader of a creative classroom needs to continue to hone an atmosphere that allows for exploration; as exploration leads to expression. Ways to do this include:

- Be encouraging.
- Emphasize involvement.
- Provide appreciation.
- Have clear but not invasive limits.
- Refrain from criticism—and sometimes even comment.
- Encourage self-motivation.
- Provoke originality.
- Allow for flexibility.
- Release control.
- Model such traits.
- Acknowledge creative thinking when exposed in the classroom (otherwise a student may not know they are being creative!).
- Model respect for art, humans and society.
- Have high expectations.

KILLING CREATIVITY

There are a few everyday actions that an art teacher should try to AVOID while nonchalantly and objectively promoting creativity: *Answering, Image Flooding*, and *Copy Work*. Overall, the goal is to help students become more intrinsically motivated, that is, they begin to be motivated by inner reasons for creating, rather than by external reasons such as a good grade or pleasing the teacher.

Answering. A student asks, "What color should I make this?" A teacher instantly answers, "Purple." It is a natural reaction to help someone who asks a question however; straight answers make the student RELY ON THE TEACHER. Rather, we want students to learn how to find their own answers. Let's try this again: A student asks, "What color should I make this?" The better teacher reply is, "Well, what do you think?" Student, "I sort of like this blue, but it blends into the foreground." Teacher, "Is there a way you could alter the foreground a little to make it work?" Or "Are there other colors that you've already used that you could try for that?"

If the teacher bluntly answers a student's questions, the student (or the class full of students) will come to rely on the teacher to make choices for him/her. Of course, it is easier to just give an answer straight out so everyone can get on with the process—but after a few times of NOT giving answers, students will quit asking questions in manipulative ways and the class will become even easier to teach. Be transparent with the students and tell them why you are answering their questions with a question (that you want them to make decisions based on their experience) so they do not think it is a flippant reaction to them.

When a young teacher first makes the decision to be a teacher who answers a question with a question, it will be a difficult transition. It is common to revert to answering

students straight out. Just try to be cognizant of it and try to avoid doing it again. In the meantime, some good responses to student questions are: "What do you feel about it?" "What motivates you?" "How can it be most relevant to your life?" "What can you do about it?" "What color is associated with the feeling you want to show?"

The question an art teacher NEVER wants to hear is, "Is this how you want it?" Such a question means that the student does not care about the work—but does care about pleasing the teacher (or getting a good grade).

On the same note, another way teachers traditionally answer student questions is by drawing on student work. This is the worst possible answer or suggestion you can give a student. NEVER draw, paint or construct anything on a student's work. A teacher's mark takes ownership away from the student. Again, such an act is just too "easy." The student, who did not mind that you drew on his/her work, probably does not care much for his/her art. Likely, he will continue to hound the teacher to do this and that—until the work is completed (by the teacher—not the student!)

Sometimes it is necessary to "show" rather than tell. For this, I might take a scrap piece of paper and draw on it and then ask the student if he/she understands. If so, I will take that piece of paper away and leave the student. I take the paper because if I leave it there, the student will look at the paper for answers and not what is in front (or inside) of him or her.

Image Flooding. I stole the term "image flooding" from Marvin Bartel. It is a term used to describe the several images of past student work that a teacher traditionally shows to students when beginning a "project." Opponents of such a normative process argue that these images guide the students to make art "like this" instead of making art that is intimately "like themselves." Bartel outlines these reasons why teachers should NOT use image flooding:

- It steals the creative integrity that is fostered within the student.
- It is possible that teachers use image flooding to serve as a substitute for clear articulation of ideas and inspiration.
- Student will just have to be "creative enough" to make art that looks similar enough to the examples.
- Students who might otherwise be naturally creative will find it difficult to access their own rich storehouse of experiences and ideas after seeing such examples. (28)

Just like answering a question with a question, it is easier to teach by image flooding. Art teachers need to stop taking annual photos of "projects" with known outcomes and expecting something truly new to come out of it again and again. Remember, brave teachers are hoping to foster something "new" and authentic—not to rehash, or make, secondhand art.

Some alternatives to using visual examples of past student work require more creative lesson planning in terms of finding other forms of inspiration: music, poetry, brainstormed

ideas, questions, dialogue, and propositions linked to personal experiences. This does not mean that no examples of images (cultural references or past/present artist works) should be shared with students—in fact, the students should be encouraged to look at art as much as possible. However, it is better to show a wide range of options rather than examples of a pre-conceived end product. Share examples of art that are vastly different from each other (performance, design, painting, etc.) yet revolve around the same concept (consumerism, love, etc.). This helps push students to places they may not have considered being. Other tactics might include sharing imagery AFTER the artwork is complete to allow for finding similarities and differences between newly created student work and other images. Or look at images of art separate from the studio experience and have several days throughout the year devoted to looking at art found in books, magazines, PowerPoints, etc. The more students understand the depth and breadth of contemporary art and art's history, the more they can see how wide the playing field is.

THEME	HISTORIC Example	CONTEMPORARY Example
Body	Greek statues, "David," Egyptian norms	Yoko Ono "Cut Piece," James Luna, Jenny Selzer
Death	"Holbeim Ambassadors," Egyptian Pyramids, Qui Shi Huang	Angelo Filomeno, Day of the Dead, Asmat Poles, Kane Kwei coffins
Earthworks	Stonehenge, Dolmens, Avebury Circle, Mammoth huts	"Spiral Jetty," Andy Goldsworthy, Nancy Holt, Agnes Denes

Copywork. Making replicas of old "Master" artwork is an example of "secondhand" art and a form of copywork that is too prevalent in high school art classes. Such assignments allow for no personal attachment or creative uncovering because the end product is known and the problem has already been found or solved. I do advocate art students look at art in magazines, visit galleries, read art books, and go to museums. There is much to learn from the past and contemporary teens often do find inspiration in old artworks. Expose students the nuances of Van Gogh's impasto or the short choppy strokes of Picasso's brush. Point out the limited color palette of Rembrandt, or the crisp lines of Estes. But let us not mandate students to "make art like" _____ artist.

London, in No More Secondhand Art, (29) eloquently presents and supports an argument against copywork. London asserts that one will never know what life was like for Monet, Van Gogh, or any other artist who is dead or alive. Therefore, since contemporary teens cannot feel the dead artist's emotions, or live their lives, they have no business making art "in the style of" another human. London wonders if a Van Gogh copyist wants to experience the emotions, and perhaps the illness, that Van Gogh himself underwent to achieve the genuine torment/torrent that is the backbone to his painting? A Van Gogh painting would not be a Van Gogh painting sans the life of Van Gogh.

Like image flooding and answering questions, formula drawing is an easy way to teach (for a while). Formula drawings occur when a teacher stands in front of the class and has the

students draw along with him/her—a few circles and a few key lines and... wow—a seagull! Even an easier way to teach copywork is to hand out a "How to Draw" book and let the students draw what is in the book. What happens when a student doesn't have a desire to draw a seagull, car, monkey, or something else in the book? Furthermore, where is the creativity, deep dialogue and critical inspection?

Below I've copied ten "creativity killers" posted online by Marvin Bartel. (30) I enjoy these because they make the TEACHER aware that he/she has the power to KILL creativity.

- *I Kill Creativity* when I encourage renting (borrowing) instead of owning ideas.

- *I Kill Creativity* when I assign grades without providing (or receiving) informative feedback.

- *I Kill Creativity* when I allow cliché symbols instead of original or observed representation of experience.

- *I Kill Creativity* when I demonstrate instead of give time for practice.

- *I Kill Creativity* when I show examples instead of define problems.

- *I Kill Creativity* when I praise neatness and conformity more than expressive original work.

- *I Kill Creativity* when I give freedom without focus.

- *I Kill Creativity* by making suggestions instead of asking open questions.

- *I Kill Creativity* if I give an answer instead of teaching problem solving experimentation methods.

- *I Kill Creativity* if I allow students to copy artists.

VII. Brave Art Paradigm

Brave art falls within a holistic paradigm that has to do with expanding student awareness about how they inter-connect to the world via nature, BodySelf and community. It is about connective discovery—playing, making, sharing. I can help people understand that what one does and thinks makes a difference to the world. It enables a sense of community. Those who tend to the holistic in education have a collective goal of transformation -- transforming humans to be more like themselves—more authentic.

Peter London, Parker Palmer, Pat Allen, Frederick Franck, Rachel Kessler, JP Miller, Rollo May, Lauren Campbell, and J. Hall are some holistic art education authors. I highly suggest Peter London's books No More Secondhand Art and Drawing Closer to Nature. They both directly talk to the artist and teacher and provide encounters for a teacher to tweak and use in the classroom. On page 305, in Drawing Closer to Nature, Peter describes the power of the holistic paradigm:

> Two principles, then, drive the holistic paradigm of art education: (1) A person who is developed and aligned in mind, body, and spirit, naturally and automatically is graceful, powerful, and full in the expression of all aspects of their life, and (2) the urgency to say something important to someone of importance to us makes us articulate.

> It is my contention, based upon the practice of this approach for 20 years, that a teacher who models congruence of mind and body and spirit, and who employs a curriculum and pedagogy that attend to the mind and body and spirit of each student, can help each student transform a graceless, weak, anxious, and fractious expression to one of grace, depth, power, and even wisdom. Anyone seriously educated, in mind, body, and spirit, and encouraged to address the important issues of their life, in their moment and place in history, will express themselves with fullness, wisdom and clarity. That is, they will be, in their person and in their expression, artistic.

On page 19 of the March, 2011, issue of National Art Education Association journal, Laurel H. Campbell also stresses the idea of contemporary holistic art education as aiding humans with life's natural transformative process. She provides nine lovely, applicable and doable components of a holistic curriculum; as one that fosters:

- Openness, trust and acceptance.
- Ethical and caring relationships with each other and the natural world.

- Social responsibility and democratic principles.
- Development of all dimensions of the person/student.
- Collaboration/cooperation rather than competition/comparison.
- Seeking connection/interdependence rather than alienation/independence.
- Hospitality, harmony, and peaceful living through community.
- A balance between intellect and intuition or balance, inclusion, connection.
- Promoting transformative learning through authentic experience.

PRODUCT vs. PROCESS

Product (thing inspection) versus process (creative exploration) has been a debate at the center of art education circles for some time. I do not discount the product-related values of craftsmanship, skill, pride-in-work, and quality; however, we prefer to see such variables linked with sacred appeal via intentional meaning-making.

Products. Perhaps it is easiest to explain brave art by showing what it is NOT. Brave art is not about project work. A "project" in art class is a lesson that revolves around a "make this" structure. When all students are given the same materials and told to "go" is what I call the "Okay, Go!" method of teaching. Okay-Go projects involve teacher-directed learning, little personal involvement, no practice and a known outcome. These types of projects are not lessons in creativity. Sadly, many people still expect to see and make project-work. [BTW, the band OK Go named itself after their high school art teacher!]

Project work is often rampant under the header of "multiculturalism." Education has rightly incorporated multiculturalism into its canon as it tries to revise the Euro-centric curriculum of its past. However, too often, good intentions become technique-based "projects" that run the risk of appropriation. Appropriation refers to the use of borrowed elements for the creation of a new work. If not transparent, the term can be derogatory, and teachers run a risk of misrepresenting the historical, social and spiritual context from which meaningful traditions and cultural expressions are born.

For example, consider a lesson in Native American art that might include learning about a "dream catcher." The ease of the Internet allows teachers to acquire instant "lesson plans" regarding the subject and most involve making (not creating) a dream catcher using wire, yarn and feathers. Many of the catalogs art teachers use to purchase supplies sell dream catcher kits. There are even kits for making earrings, car ornaments to hang from windshields and key chain dream catchers. Sadly, some teachers purchase these kits and provide students with time to assemble them and perhaps let them pick their own colors and embellish them with special stones or feathers or something. Recall, such embellishment is a bottom-level [expressive] form of creativity. Most likely there is no talk about the "sacredness" of the item, which is disrespectful to the art form and to the Native people who consider a dream catcher to be a unique part of their culture.

According to Native tradition, dream catchers should resemble a spider web and hang above a baby's cradle. The web filters out nightmares, allowing only good dreams to pass through to the sleeping child below. People make real dream catchers in intricate,

ceremonial steps that include giving thanks for the spirit of the wood, plant fiber cords, sinew, and owl or eagle feathers (depending on the gender of the baby). These materials are not permanent to belie the temporary-ness of youth. Traditionally, feathers are not even used for adult dream catchers. Are teens assembling dream catcher kits in a high school art class using sacred supplies or honoring such traditions?

However, the idea of "catching dreams" is very inline with the brave art paradigm. Instead of copying a dream catcher, imagine an interdisciplinary studio experience about personal dreams, catchers, temporary/ephemera products, ceremony, and something sacred that might be inspired by dream catchers, but not made to replicate them? How do teens dissect the good dream from the bad dream? What form does their protectors take? What supplies (or defenses) do students carry for protection? Perhaps such a discussion could be enhanced by Langston Hughes's "A Dream Deferred" poem:

> What happens to a dream deferred?
> Does it dry up
> like a raisin in the sun?
> Or fester like a sore--
> And then run?
> Does it stink like rotten meat?
> Or crust and sugar over--
> like a syrupy sweet?
>
> Maybe it just sags
> like a heavy load.
>
> Or does it explode?

Can you see how significant a conversation about the concept of "dream catchers" could be to teens in a true BraveArt framework?

Art One Curriculum. Given an awareness of a contemporary construct, "art class" should no longer revolve around the technique-based studio arts. However, it is a fact that the majority of students who enroll in an art class will have the expectation of learning to draw. Many young people equate the ability to draw realistically with being an artist, and, in the beginning, they will ask for technique. It might even be true that without the ability to represent things convincingly students may continue to feel inadequate in the arts. Teaching observational drawing does not foster creativity, but it can help build confidence as students delve into more expressive and creative work. Posner's article, "How Arts Training Improves Attention and Cognition," states:

> "Recent research offers a possibility that focused training in any of the arts strengthens the brain's attention system, which in turn can improve cognition more generally. Furthermore, this strengthening likely helps explain the effects of arts training on the brain and cognitive performance that have been reported in several scientific studies.

- *We know that the brain has a system of neural pathways dedicated to attention.*
- *We know that training these attention networks improves general measures of intelligence.*
- *And we can be fairly sure that focusing our attention on learning and performing an art—if we practice frequently and are truly engaged—activates these same attention networks.*
- *We therefore would expect focused training in the arts to improve cognition generally."*

Observational drawing can thus provide students with a way to quiet their mind, to learn focus and to then open up to other learning activities. What a gift to give a person!

So how does one bridge the contemporary world with traditional skills? I set up a curriculum that teaches observational drawing and various media techniques during the first few weeks of the Art I semester. Techniques and devices to help people learn how to "draw" or mix colors are only meant for beginning artists, so high school is probably a good place to insert such training. If teachers were not there to push students and teach them some tricks, there is little hope for massive improvements towards crafting abilities. In other words, it is the art teacher's role to guide students toward some legitimate successes and improvements in their art making skills; however, learning technique is easy if taught correctly and more importantly, if the student takes the initiative to practice. Of course, learning a technique well takes prolonged effort and practice —and that is not so easy! Overall, an art teacher must decide if he/she is honing aware artists/humans or nice products. [See more in the Appendix: On Technique.]

Since brave art is more interested in meaning-making than product-making, it is important to push students to think conceptually almost immediately. I begin the push with their at-home assignments, so they have a safe and quiet place to practice making marks and taking risks.

One of the at-home assignments I give is what I title "Word." For this, I have students write their favorite word on a piece of paper and put them in a group can. It can be a real or fake word. Each week, we pick a word out of the can and make art based on that word. At first, students are pretty generic with their interpretations: love almost always comes in the form of a heart; death is a skull; time is a clock. At first, this is fine, and we sit in a circle and talk about things. Can we be more personal? More creative? Braver? Soon they try to break from the norm. By about week four, we start to get some truly interesting ideas. This NEVER would happen if we did not discuss and share the work. Students must be aware of possibilities before they can fathom them.

Art Two+ Curriculum. By the end of Art I, and in all subsequent semesters, I shift the curriculum's focus to one that is entirely conceptual and holistic in nature. However, I still uphold the artistic values of craft, intent and practice. At this point technique enters into the curriculum via "demo days." On demo days, I teach things such as paper making, batik,

book arts, artist trading cards; and show a variety of uses for the technique. I include interesting cultural facts and post links and references on the class blog.

I like demo days because I am aware that perhaps "John" doesn't want to make paper for an art piece, but he might be curious about how to do it and at least had an opportunity to try it during the demo class. Most often, a few students in the class will love the "technique of the day" and will take off and explore many ideas and probably teach us all something new about paper-making (or whatever technique). Perhaps that person will inspire someone else to use it in interesting ways—or not. Most importantly, "John" will not be forced to endure a two-week art-making process in which he had no interest in participating. "John's" only choice, if not inspired to make paper yet forced to, would be to misbehave, do enough to pass, or sleep in class. By allowing choice, he has at least been exposed to—and probably has fostered an appreciation about—the process. In the future, he will know how to approach the process if he chooses.

Students who opt for an Art II or beyond class are, in a sense, entering into a contract of engagement. By this time, the teacher and student have formed a trust structure. The student has met his or her BodySelf and will be able to delve into "deeper" and more meaningful discussions and art-making processes.

METHODOLOGIES

These methods are not radical in nature; however, they do advocate for a good amount of research into a topic (sometimes by the teacher and sometimes by the student) and can educate and inspire everyone. The contemporary art teacher utilizes whatever tools are necessary to inspire inspection and foster transformation, and this requires putting together dynamic presentations rather than the mere 10 minutes of front-loading information and saying, "Okay, go!" Instead, the leader approaches planning as a professional task. Framing art experiences may include as hands-on reflective writing, story sharing, visualization, relaxation exercises, breath work, sounding, non-competitive games, readings, affirmations, brainstorming, role playing, music and meditation. The goal is to make the art learning within the classroom be both relevant and engaging during EVERY step of the PROCESS. By the end of the presentation experiences, students should feel inspired and excited about exploring meaning—not afraid of doing it "right" or merely "getting it done."

The four presentation methods described in this book terminate with an unknown "product" and can cause trepidation with some teachers because they mandate that the students will control the end events—not the teacher/leader. However, as time passes, teachers learn whatever the student's come up with far surpasses whatever idea he/she imagined! All brave art teachers know a dozen heads are always better than one.

I recommend a combination of these formats in an Art II (or a 2nd semester Art I) classroom. There is no such thing as a cut-and-paste lesson plan. The ideas I present below will need the teacher to alter them for his/her individual class depending on the maturity level of the students, the group's cohesion and past teachings. These four teaching methods are:

Visual Thinking Method: (Theme-Based) Teacher initiates theme and inspires students to think about a contemporary/personal idea to research/explore and then organize their thoughts, feelings and perceptions to make personal art about it. Students will have free reign to solve/engage with the theme as they wish—using any media/um desired.

Studio-Solve-It Method: (Problem-Solving-Based) Teacher initiates theme and inspires students to think about a contemporary/personal idea to research and then make personal art about it. Students will have rules to creatively work within to solve/engage with the theme they wish—medium may be limited in scope, yet open enough to foster creativity.

Research Method: (Inquiry-Based) With this method, students are inspired to think about themes and ideas that inspire them to make personal art. Students fill out a study plan and are released to work creatively to solve/engage in an art practice experience.

Encounter Method: (Problem-Finding-Based) London advocates this method in his teachings. It students to trust and value what they have to say. It involves inspiring students via discussions, poetry and other exercises to foster imagery that is both emotional and immediate, and then formed around an "encounter question" that sparks BodySelf dialog. This question must be open-ended, age appropriate and personal.

VISUAL THINKING & STUDIO SOLVE-IT METHODS

The "Visual Thinking" and "Studio-Solve-It" methods are exactly alike in presentation and format until the end of the experience (step "h" below). At that point, what the students are asked to do becomes open-ended with the Visual Thinking method; and more defined with the Studio-Solve-It method. The same class can be working on both methods at the same time.

To show these methods, I've outlined an experience that I've successfully used with a high school class titled "What Consumes You?" The experience revolves around a contemporary and personal idea about consumption. The setup of the experience begins exactly the same: (a-c) with student pre-knowledge discussion, (d) teacher-led inspiration/research about consumption, (e) variety of contemporary and historical art images, (f) a check for understanding, (g) practice/discuss art making ideas. These methods deviate at step (h) and reconvene for a reflection period in step (i).

Pre-Knowledge

 a. Define. "What does the word consumption mean?"

 b. Discuss differences: Consumes, consumed, consuming, consumer.

Entice

 c. Class Brainstorm.

- "What have you consumed today?" <u>List on board</u> (water, coffee, gum, pencil, aspirin, Twinkies) "Did you buy these items? Your parents? Or where did you find them?" "Why did you consume these? Did you need, want or desire it?" "What is consumerism?" "Is it good or bad or neutral?"

Research

 d. Provide facts/images via PowerPoint about consumption:

- We have used more natural resources since 1955 than in all of human history.

- The average American generates 52 tons of garbage by age 75.

- Every day an estimated nine square miles of rural land are lost to development.

- Americans own roughly one-third of the world's automobiles, drive about as many miles as the rest of the world combined, and are far and away the largest per capita producers of carbon dioxide.

- Americans constitute 5% of the world's population but consume 24% of the world's energy.

- On average, one American consumes as much energy as: two Japanese, six Mexicans, 13 Chinese, 31 Indians, 128 Bangladeshis, 307 Tanzanians, 370 Ethiopians.

- Adults and teens will spend nearly five months (3,518 hours) next year watching television, surfing the Internet, reading daily newspapers and listening to personal music devices.

- A consumer culture is inundated by an unending parade of commodities that maintains a societal preoccupation with the ideals and values of consumerism via: magazines, television, billboards, commercial radio, and Internet.

- TV feeds consumption: The latest Nielsen Media Research report shows that the average American spends four hours and 35 minutes watching television per DAY. National and local commercials now total an average of eight minutes of every half-hour show. So the average viewer is watching 40 minutes of commercials a day or more than four-and-a-half hours weekly. Discuss ramifications of this.

 e. Show slides of various artists who work with the idea of

consumption: Peggy Diggs, Kate Bingham, Chris Jordon, Michael Landy, Janine Antoni, Susana Bettag, Emily Eveleth, Jen Mantia (be sure these are varied and compelling!)

Check for Understanding

f. Re-define consumption and link to previous slides. Is the definition broader than the student's initial understanding of it? How does consumption relate to the following facets:

to do away with completely: DESTROY <fire consumed several buildings>

to spend wastefully: SQUANDER: USE UP_<writing consumed much of his time>

to eat or drink especially in great quantity <consumed several bags of pretzels>

to enjoy avidly : DEVOUR

to engage fully : ENGROSS <consumed with curiosity>

Practice

g. Pass out paper/chart. On top of the chart, write the words destroy, squander, devour, engross. Have students write down their intake of objects, images & popular ideas into their home, body, or daily life as they pertain to these categories … Share answers as a class.

Notice how the idea of consumption began as something "we" consume – and it broadened into something that can consume "us?" Which drive is more powerful to you? What CONSUMES you?

Make *Studio*

h. (*Visual Thinking Method and Studio Solve-It methods diverge here.)

*VISUAL THINKING METHOD

For this method, students will be released to make a personal statement about "What Consumes You?"

h. Students will be released to select an issue that deals with their personal idea/experience and research ideas to make art with that answers the question: "What Consumes You?" Perhaps students will travel to a recycle plant, do Internet research, read, do a survey, or otherwise inform their art. They may use any/all resources, materials they can find to inspect this topic with – including acting, installation, puppetry, painting, sculpture, digital media, etc. Students will also submit research and sketches to support independent work.

EXAMPLES of student submitted responses:

- Rachel baked cakes and stuffed them into a tire, which she wore around her waist. Rachel was tall and slim, and admitted that she saw herself as fat and round … that what she ate consumed her to the point of obsession. The class photographed her modeling this costume for documentation.

- Josh cut open a basketball and stuffed it with report cards, health reports and other things. He mounted it on wood flooring and stated he was consumed by finding a sport scholarship for college.

Reflect.

OR

*STUDIO SOLVE-IT METHOD

For this option, students will be given specific media and directions to openly solve the challenge while making a personal statement about "What Consumes You?" as outlined here:

 h. Revisit slides of Jen Mantia's artwork titled "What Consumes You?" Tell students about Jen's art show where she asked more than 600 people from across the USA to alter a life-size pre-made plaster cupcake to depict the question "What Consumes You?" She installed this show in a gallery in Miami.

Provide each student with a pre-made plaster cupcake (as an example) as a symbol of consumption/consumerism and instruct students to design, alter, consume, destroy or add-to their own cupcake to answer the same question. Install collection in a public place. Provide photographic documentation time of event.

Reflect.

OTHER

RESEARCH METHOD

An interdisciplinary research classroom is the process of a person's approach. Such an approach was advocated by Dewey in his <u>Art as Experience</u> text when he stated, "The child's own instincts and powers furnish the material and give the starting point for all education." (32) With this method, students decide what they will study, select their goals and describe how they will document this process. Dictionaries, encyclopedias, magazines, the Internet, interviewing, and other forms of research are all components of working in an interdisciplinary manner, as is learning a new medium such as painting, poetry or digital imaging. This research combines installation, painting, sculpture, assemblage, collage, digital art, video and a plethora of other options. This approach allows students to find personal and social meanings posed by life itself and provides the most authentic and

relevant of art experiences for students.

Facilitating an interdisciplinary environment is not as daunting as it may sound. The teacher does not have to be proficient in subjects and materials the students wish to explore. The students' natural curiosity and motivation will help them practice and research what they need to know. Often the teacher will find he/she is learning along with the students, and this is good.

Such leadership ideals force teachers to brave new territories to lead more significant, and less dogmatic, experiences in their classroom. I advocate teaching in an interdisciplinary manner in both dynamic and latent ways, which means the teacher/leader must:

1. Trust his/her students.
2. See his/her students as human.
3. Release control.
4. Trust art.
5. Be brave.

Example: Interdisciplinary Study Plan:

a. Overall goal. "My goals are _____."
b. Declaration of artwork to be completed. "I will create _____."
c. Schedule needed to complete artwork. "I will research for ____ hours, make ____ by ____
 (date), and complete art by _____ (date)."
d. "I will document my process by _____."
e. Resources needed. "I need my teacher to _____."

Pam Taylor's book Interdisciplinary Approach to Teaching High School Art offers a thorough investigation into many approaches to this subject. She offers antidotes and resources from teacher-tried initiatives and reminds us that this approach can endlessly branch into collaborative, visual-culture based, experiential service-providing, and team-teaching experiences. (33) [I highly recommend her book.]

[The "shower" story in the Introduction is a good example of interdisciplinary work in the classroom].

ENCOUNTER METHOD

To provide an example of an encounter method, I am sharing an experience I titled "The Things We Carry." (34) I have successfully used this in both high school and undergraduate settings. To see more examples of encounters for the classroom, please read Peter London's texts as mentioned.

Entice.

1. Write "Things They Carried" on the board. Underline THEY (referencing a short story by Tim O'Brien).

2. Cut up 17 (or as many students are in the class) sections of Tim O'Brien's "Things They Carried" story for students to read aloud.

3. Pass strips out in order.

4. Have the first three students read the first three strips:

- *They carried USO stationery and pencils and pens.*

- *They carried Sterno, safety pins, trip flares, signal flares, spools of wire, razor blades, chewing tobacco, fingernail clippers.*

- *Twice a week, when the resupply choppers came in, they carried hot chow in green cans and large canvas bags filled with iced beer and soda.*

5. After reading first three sections stop students and ask them who the "they" in the title is referring to? Discuss.

6. Begin reading strips again. Go through all 17 sections (use more as needed).

 - *Taking turns, they carried the big PRC-77 scrambler radio, which weighed thirty pounds with its battery.*

 - *They carried the traditions of the United States military. They carried grief, terror, longing and their reputations.*

 - *The carried the emotional baggage of men and women who might die at any moment.*

 - *They shared the weight of memory.*

 - *They carried infections.*

 - *They carried chess sets, basketballs, Vietnamese English dictionaries, insignia of rank, Bronze Stars and Purple Hearts, plastic cards imprinted with the Code of Conduct.*

 - *They carried diseases, lice and ringworm and leeches and paddy algae and various rots and molds.*

 - *They carried the land itself, Vietnam, the place, the sod -a powdery orange-red dust that covered their boots and fatigues and faces.*

 - *They carried memories, and for the most part, they carried themselves with grace and dignity.*

 - *The whole atmosphere, they carried it, the humidity, the monsoons, the stink of fungus and decay.*

 - *They carried gravity.*

 - *They took up what others could no longer bear ... and often ...*

 - *They carried each other.*

7. Pass out paper with all sections on it (not cut up) so students can read as a whole. (Cite reference so they can find the text if they desire.)

 a. Circle "THINGS" on the board.

 b. Ask students what "categories" of things are in the story. Write these

on the board: survival (food), job related, survival (geography), personal goals, love, family, memories, etc.

8. Pass out the following sections and continue reading aloud. (Provide all sections on the flip side of #5 handout above, so students can again read passages in entirety).

- *Henry Dobbins, who was a big man, carried extra rations; he was especially fond of canned peaches in heavy syrup over pound cake.*

- *Dave Jensen, who practiced field hygiene, carried a toothbrush, dental floss, and several hotel-size bars of soap he'd stolen on R&R in Sydney, Australia.*

- *Ted Lavender, who was scared, carried tranquilizers until he was shot in the head outside the village of Than Khe in mid-April.*

- *Dave Jensen carried three pairs of socks and a can of Dr. Scholl's foot powder as a precaution against trench foot.*

- *Norman Bowker carried a diary.*

- *Rat Kiley carried comic books.*

Check for Understanding.

9. Ask: After listening to those new sections, how do the "things" change per "person?" Similarities/differences? Physical size, health, coping strategies, rank/title, priority and practicality.

Practice.

10. Ask students to look through their items they have on them/carried into class today.

- Have them find one item that represents who they are as a student, one as a boy/girl, one as a friend, and one they think will be unique to who they are (physically or other). Arrange piles to show a hierarchy of importance.

- Have class walk around and look at the piles.

- Discuss how these items relate to the task.

- Compare/contrast as a "whole" via what students in the class all carried that they have in common (pencils?) and how things change for personal reasons?

Practice

11. New discussion. Does anyone carry something intangible? (List these on the board) Ex: fear, hope, missing a parent, love, dreams, guilt ...

12. Give each student a section of paper. Have them write their name, and what they carry (in the style of the handout). (Example: Jodi, a teacher, carries her hope for her students in her heart and their grades in her laptop.)

13. Collect papers and randomly redistribute sections to students.

14. Cross out THEY on board and write WE.

15. Have students read their random section from 12 above aloud in circle to describe the things "we" carry.

16. Have students give the cards back, and then have them sit down and write immediate notes/thoughts on back of card regarding insights to what they carry – may help form art encounter. Ask for silence and just let them write, doodle, think, incubate.

17. When appropriate, ask students – what is "heavy" to them, "light" ... what would they like to not carry that they do; what can they put down? What would they like to carry? How can they change their load? Provide more time to write/reflect.

Make.

18. Present ENCOUNTER QUESTION on board and a sliver of paper. Sometimes I put them in envelopes, to symbolize importance or treasure.

19. An encounter question is an open ended question that provokes creative inquiry of a relevant topic that relates to the student's experience. The question must equate to the level of trust built in the room. Meant to motivate and push and be the main impetus to an extended art "project."

20. The question is non-rhetorical, personal, and age appropriate. Therefore, the answer is unknown to the teacher. Because of the abstract-quality of this, confusion is initially expected due to vagueness of question – this is GOOD. (If bombarded with questions, just answer, "However you wish!")

21. Note: you want to present the question with perfect timing, when students are most inspired. Pre-plan the event to make sure no one is out of the class, sharpening a pencil or otherwise distracted.

22. For this encounter, the question for inspiration is:

"What does that which you intangibly carry look and feel like? Give your hopes, fears, dreams and/or other intangibles weight, color, texture and/or form."

23. Students disperse and begin working on encounter using any media desired. Encourage BodySelf dialog and avoidance of pre-planning. State a due date.

Reflection *as appropriate to the group

FRAMING MEANING

The preceding examples of teaching methods offer the Art/Teacher a variety of ways to talk about issues students face today. Whatever method one uses, London reminds us that it is good to ask if the experience provides for meaning. (35) Here are some criteria for curriculum.

Experiences in the Art Room Should Be:

- Grounded in the lives of our students. Curriculum should be rooted in the needs and experiences of the students.

- Participatory and experiential. Are the experiences made from "first-hand" experience?

- Hopeful, joyful, kind, true and visionary. Does the art-making process create trust and care for others in the group?

Evaluation of Student Experiences Entails:

- Where and in what ways was the student brave?

- Did the student take some risks with creativity, rather than submit something predictable?

- Does the student experience any surprises, roll with the unexpected, take it further than initially planned?

Evaluation of Teaching Experience Entails:

- Was I able to make students feel comfortable enough to go as deep as we are ready for?

- Was the group as a whole ready to "go there?" Or do I need to build more trust-structures before trying again?

- What will I do differently next time? How can I be better? (29)

SHARING

Sharing/reflecting is the most important part of the brave art paradigm, and variations of it are spattered throughout this book. Sharing is "voice" and voice is empowerment. Psychologist Amanda Goza is a woman who uses "change talk" in her everyday work. She understands the power of reflection and its ability to be a catalyst to change (recall transformation is the goal of high school art making), and describes it here:

> "Put simply, reflection is the expression of the sound that the art has made. It is the ripples in the pond that result from the toss of a pebble. [The goal of the contemporary art classroom] is to provide a space where everyone can express these ripples, these sounds, through a combination of literal voice and art making." She goes on to expand reflection's importance by saying, "...maybe the most potent learning experience in reflection on another's work is what is reflected back to you—hearing your thoughts about another's work and having them accepted, validated, valued, is a powerful learning experience." (36)

Group reflections offer students an invaluable opportunity for learning and insight—more

than any one teacher can offer—by creating a three-dimensional feedback experience of differing perceptions, perspectives, responses and suggestions. The sounds, which come in the forms of responding, sharing, and listening to (and about) the teenager's art, are of the utmost importance to the artist. Such reflections expand the life experiences of the student that exist beyond his or her "one story," while at the same time exposing similarities and differences shared by other students.

Teachers must learn how to build cohesive and encouraging listening groups. Though mere visual interpretation is fine for professional artists in museums and galleries, it is not enough for a teenager. A teenager needs to hear and feel "heard." Group reflections offer a way to validate humanness.

Validate Humanness. Imagine sharing something after spending large amounts of time on it and then receiving no acknowledgment (or validation) for your efforts. I have witnessed art teachers do this more often than not when they collect the "lesson" after a week or two of studio work and either grade it with little to no student input or post it on a wall for a quick, one-dimensional critique from one voice: the teacher's. Such lack of compassion does not validate the human component of the art: the value of the student's voice.

Earlier in this book I talked about the necessity and joy of "slowing down" the curriculum—not dumbing it down. This involves taking steps to ensure the students are talking and sharing and supporting the content. I mentioned doing this at the beginning of every class and the beginning of a semester, via icebreakers. I also advocate slowing down at "critique" time (aka "reflection") time. In my classrooms, we devote as much time as needed to discussing EVERY student's art while linking past knowledge with new knowledge. This may take one or more entire class days, but because reflection is so foundational to a high school art class, time does not matter. Students know they will be sharing their work, and this makes them want to present work of which they are proud. Given this, it is important to dignify their attempts and provide them with a sense that what they made has value and what they have to say matters.

Do not expect life-altering conversations the first few critiques/reflections, as trust and etiquette will emerge over time. It is important to establish (and model) ways to talk about the art before people become comfortable sharing themselves. London provides three main goals to keep in mind, and model, during dialogue: Avoid value judgment, do not interpret, and focus on descriptions. (37)

- Avoid value judgment. This includes overt praise or displeasure. Saying things such as "Really great work!" or "Great job!" are value judgments just as much as "I didn't like the way you painted this hand," or "Your project was too simple for this level in the course."

 Once aware of this concept, I realized just how often I walked around the classroom and repeated the judgment: "I love it!" Until then, I wasn't aware that nice words are judgment words, too. I suppose it is a natural response when scanning art, but it doesn't provide the type of feedback a student

needs. Students are familiar with value judgments and even find themselves asking, "Do you like it?" Of course they want their teacher, whom they respect, to like their art. To that question, I merely respond, "Do you like it?" or "I am impressed with the way you've overlapped the head over the tree— how very brave of you!" Remember: trying to please the teacher is no reason to make art.

- **Do not interpret.** Statements such as, "Jill must be very sad because of the blue colors," or "Peter must feel manly," are not describing the art but the artist. Such statements put the artist on the defensive and/or expose the teenager to vulnerabilities about sharing his/her work. Though we know the BodySelf is directing information to the artist, it is not our job to interpret what it is saying for the artist—but rather what it makes us realize about ourselves. These realizations are best shared via descriptions, as discussed further below.

- **Describe.** A critique/reflection for teens must focus on the descriptions of the art and how it might make the viewer feel. For example, "I feel a sense of longing when I focus on the hovering cloud-like space. It is sort of like how I felt the other day at lunch when I couldn't find any friends to sit with," or "This smoky blue fog-like imagery reminds me of _____." Notice how the description revolves around the viewer's insight and feelings—not the artist's. Of course, the artist can use this information for his/her self if he/she wishes and it may help with his/her own understanding of what the BodySelf is trying to reveal to the artist.

 Notice how "describing" work solicits more than an "I like it" or "She must be crazy" response by discussing colors and compositions and mixing these observations with personal experiences to provide the teenage artist with some varied insight.

At some point, students realize multiple viewpoints can emerge from one work of art. They understand how they cannot let their own prejudices about the subject or materials temper their relationship with the viewing process. Though one student may despise using rulers, he or she may like looking at work that is straight-edged and clean. Or that some viewers tend to see most art as political, others see it as spiritual and others might delve more into the emotional impact of a work. This hodge-podge of experience and aesthetic philosophies can benefit the artist and group by providing a plethora of possibilities.

Though we learn there is no cut-in-stone-right-answer to viewing art, it is important to ensure the artist feels heard. Therefore, group conversations are also used for the following benefits:

Recognizing efforts. This offers a public forum to acknowledge the work the student put forth, without merely stating a value judgment. For example, "Thank you for being brave and trying this new approach. The way you

solicited research was masterful, and I appreciated how you helped Sally dissect her work too."

Giving language to feelings. Sharing provides an opportunity to allow the student artist to share his/her feelings and to hear those of others. It is important to not minimize students' feelings or tell them they shouldn't feel a certain way—or worse yet, give unsolicited advice. Rather, the goal is to create a "safe place" where teens can express feelings and have their humanness validated by allowing their feelings to just be. "You ARE angry. You DO feel misunderstood." Once feelings are truly heard and accepted without judgment, learning and solutions have a chance to unfold. I would add that it is good practice to befriend the school counselor. Let him/her know about the power of art and what you talk about in class. This will give you someone to talk with, and will also be someone to whom you can refer the students who seem to need an extra ear.

Honoring students as individuals. I like to ask students what type of information from the class would be most helpful to them at this stage in their work. They might respond with, "I'd like to hear what my art means to you," or "I had a difficult time with making "x" depict "x"—any feedback?" also, we honor students by asking them why they made specific decisions. Why yellow? ("Oh, it was the color of your prom dress?") Why this angle? Why in the background? This is not meant to be a critical conversation, but rather a way to learn a little about how the student thinks about his/her process. It also helps the student give meaning to the creative process.

I cannot stress enough the importance of student input at the close of a studio session. Take Aubre, for example. Aubre was in Art II, and I knew her quite well. She always took class seriously. We happened to be working on an encounter titled "I am From" and she chose to use sandpaper and a painted board to make a "performance" piece of art. For one solid week, Aubre came to class and sanded the board while sitting in the door that led to the outside (in part, to keep the sawdust out of the room). Her sanding actions rhythmically became a part of the class. When asked what she was working on, she would reply, "Art."

When it became Aubre's time to share with the class her finished "piece," she asked the group what they got from her performance. Students mentioned words like patience, longing, engine/motor—it seems they were right! They talked about the noise and their curiosity about her art. Aubre then shared with us that her dad left the family when she was a little girl, and she remembers sitting by the side of the road and stroking the pavement—for many, many days. She understood that the road leading away from the house was the last thing her daddy touched, and she wanted to touch him. She then passed her sanded piece around and asked the class to touch it—we could all feel the roughness of the "road"- and how the loss of the painting became a mark of memory.

Was this sanded piece of painted board was "pretty" after four days of sanding on it? Does "ugly" mean that it is less than art? What if Aubre just turned in a sanded piece of

wood for a week's worth of a studio grade without context or dialogue to communicate the meaning of the work? What if the grade was based only on the product itself – not the process? More importantly, what if the group of students who watched Aubre intently working all week never got to "hear" her story?

For these high school students, it was the reflecting about Aubre's work that made an unattractive piece of wood into a work of art. In the end, the art was not important. It was the strength Aubre gave to us through her own empowerment that mattered. Other students with abandonment stories were suddenly not alone with their memories, and the rest of us felt our bravery (and love) growing. It was the airing and sharing that brought us closer together. The realization that something was "said" and everybody was better for it. Aubre was brave ... and still safe.

So what is brave art? Brave art is when students grow into their humanness through conversations like this—due to bravely making and bravely sharing.

The end.

APPENDIX

PRESENTION TIPS

When presenting, I find the more I prepare, the more confidence I have. I like to think of myself as a performer rather than a presenter. The trick is to engage, engage, engage! I want students to not expect what is coming – to be awed by the process. The only way we can keep their attention is by making the experiences relevant to them. A presentation includes 1.) preparation and 2.) the presentation itself.

Preparation. My beginning art education students feel nervous before giving peer-presentations. I admit to my students that when I began teaching, I was so afraid to speak front people that I could feel my skirt shake! I further promise them that it gets easier with each day/year that goes by, although I admit that I STILL get nervous on the first day of school. I think a little nervousness is good—because it means our expectations for doing well are high.

- Writing out the entire speech is important. Then vocalize it and time it. It is also helpful to do this in front of a web cam.

- Highlight points you want to stress with a marker, so it stands out easily

- Writing things downs helps keep focus. There are always things that will distract the thinking process (hands raising, door knock, fire drill, school announcement, etc.).

• Keep text to a minimum. No more than three bullet points per slide, and if you can keep them to one core idea, that's even better.
• An audience will tend to read—and not pay attention to what you're saying. So do not give them things to read when you want them to listen.
• Check the contrast and font size (30 point font is minimum). Make sure that if you have text on the screen that people can read it.
• Use pictures to get your idea across. They're easier to remember, less distracting, and make more impact. Have stories ready and use imagery to set the backdrop.
• Backgrounds should never distract from the presentation.
• Backgrounds that are light colored with dark text, or vice versa, look good.
• Avoid black backgrounds if audience is taking notes in a dark room.
• Consistent backgrounds add to a professional appearance.
• For a long presentation, you may want to change background designs when shifting to a new topic.
• Check spelling!
• To temporarily clear the screen, press W or B during the presentation. Press Enter to resume the presentation.
• Don't use a variety of fonts.
• Fonts that work on your PowerPoint at home may not work on a computer at

school. So use common fonts.
- NEVER READ projected text to the audience! Talk about what is projected in another more personal and dynamic way.
- Prepare more than you can speak to, but also be prepared to cut your presentation short.
- Know ALL terms on slide.
- TEST all equipment/files BEFORE the day of the presentation ... Do not assume that all computers need the same plugs, support the same files, have the same fonts and/or the same screen resolution!

While presenting, move around, laugh, use your hands. Keep students involved at all times. Don't hide behind a desk. Be passionate! Here are some more tips:

- Think positive.
- Tell audience what will occur.
- Tell stories.
- Talk at a natural, moderate speed.
- Project your voice.
- Don't turn your back.
- Keep it slow and steady.
- Don't agonize over mistakes.
- Pause to let strong ideas sink in.
- Smile, joke, and laugh.
- Be sure audience knows key terms.
- Avoid: "Does everyone know _____?" or "Who doesn't know _____?
- ASK IF THERE ARE ANY QUESTIONS. End strong!

SILENCE

Not every student is going to want to contribute personal information to a group. Sometimes a student doesn't feel safe enough to share his/her work or feelings and should not be forced to speak. Frankly, we don't know what kind of peer-pressure, cultural standards, or trauma a student undergoes outside of the safe-zone of the art room. If a student generally shares but doesn't want to for a specific assignment, just allow him/her to "pass" and ask if they'd rather have a private conversation with you—or write up a reflection on paper. If a student opts to "pass" all the time, work with that student to foster trust and a sense of belonging in the group. It is okay to allow such a student to submit written reflections that will help to open up dialogic opportunities, check for student understanding, and offer the student a way to be heard, but sprinkle in ways to gently coax verbal group responses. Ask the quiet student direct questions and acknowledge whatever minimal effort put forth. The goal is to put some time into the quiet student to help build confidence and trust to increase participation and integration with the group.

The teacher must also consider how he or she is promoting silence in both good and bad ways. Are students given leeway to explore ideas, or does the teacher prompt them to give the "right" answers? How does the teacher respond to voice and/or bring underlying issues to the table? More importantly, how does the student understand how he/she will be evaluated within the space led by a teacher and peers? Recall teens are very concerned about being a part of a group and how their peers think about them. Many teens (and adults) feel that answering a question or posing a problem to a group will directly reflect upon how others in the group will label them. Teachers must recognize that silence is an active (not disengaged or stagnant) space. In other words, silence – along with dialog – fosters learning.

Silence invites introspection, meditation, contemplation and engagement. It is also at the core of reflective practice. Many galleries and museums are quiet spaces. Often they offer benches for people to sit and silently contemplate the art before them. When confronting a canvas, drinking a poem, mining a well of information, deciphering meaning, studying lines, or sensing aromas or feelings ... silence is often an accompaniment. Allow students this time of pause before, during and after the meaning-making process to calm the clamor of media, crowded streets, and otherwise overwhelming chaos that seems to surround contemporary times. Do not be afraid of silence; invite students to experience it, too. Not all silence is harmful, defensive or shy. Quiet reflection is a practice used by many people and cultures to help them cultivate holistic living. Jewish lore states, "...a safety place for wisdom is silence." Christians pray and Buddhists seek enlightenment in silence. Meditation and yoga can silence the brain to gain insight from the Body. Quakers worship as a group sitting in silence. People all over the world pay homage to victims through the commemorative practice of a "moment of silence."

CLASSROOM MANAGEMENT

Of course, in a perfect world, we would not need to discuss classroom management; however, without some set of stated public expectations, things could get sticky. Frankly, by the time a person becomes of high school age, he/she inherently knows what type of behavior is expected from him/her in a classroom and good behavior does not have to be negotiated—it is expected. For this reason, I do not advocate the "Let's-make-class-rules-together" approach at this level of education. Instead, I tell the students how silly it is to have such a discussion due to their maturity levels, and tell them that the terms of behavior for the class are not "rules" but "rights." I let them know that I call them "rights" because I believe every student has a right to a good education and I will not let other people interfere with this. I do not just give this concept lip service, as I believe that education is empowerment from the center of my core. Students sense my passion and seem to inherently take heed of my declaration. In fact, in my last five years of teaching high school, I never once sent a student out of my class for bad behavior. I've surely had private discussions in the hallway when a student was acting out, but generally he/she will confess something "else" is happening in their life and they need a moment to chill.

The classroom rights I use, as alluded to earlier, are based on the concept of respect:

Classroom "Rights"

Respect yourself!
Respect others!
Respect supplies!
Respect your art!

All we really need to say is simply to:

Be kind.
Do good work.

Besides having this visual contract in place, trained teachers also know that there are non-verbal communications that can help maintain a group. Often these actions occur before something goes awry. These simple options are better than getting into a word-war with a student:

- Stand next to someone who is talking— presence will generally quiet him or her.
- Get eye contact.
- Believe in the vision.
- When a change occurs for the better, acknowledge (don't praise) the behavior.
- Ignore obvious efforts for negative attention.
- Call a student by name, or drop his/her name into the lecture
- Use classroom procedures to create consistency.
- Avoid interrupting students when they are engaged in a process.
- Introduce information in increments—do not "front load" information all at once (a.k.a. "Okay, go!" teaching method).

- Write down directions to avoid confusion (Make teacher boards to use over and over that show how to do things like shade, use graphite paper, etc.)
- Intervene quickly if needed.
- Avoid extra credit—hold students accountable.
* Have high expectations.
- Try phrasing things in a positive manner.
- Keep a notebook and record bad behaviors in it. Date and time each recording, and when applicable, present this to the student, his or her parents, or an administrator. Generally the small infractions add up to tell a bigger story. By having a record of this information, you have evidence to suggest a problem. (See Behavior Chart at end of section.)
- Use "Behavior Contracts"—attach infraction sheet (if applicable) and have students write out what they did wrong and what they will do right. Have them sign the sheet. Teens are smart enough to know that a signature has meat. Their signature is the equivalent of admitting they were wrong – this tactic, as strange as it may be to implement at first, seems to really work with this age group. (See end of section.)
- Engage, engage, engage and engage some more.

Besides advocating a high degree of honed respect in the classroom, **the best thing a teacher can do to circumvent behavior problems is to provide students with relevant studio experiences that are rigorous in nature and help form relationships.** Engaged students are involved students. Involved students are too busy to throw pencils or ask to leave the class to get a drink. If students are interested in what is happening in a classroom, no one has to force anyone to do the work—they just do it out of respect for themselves, others and their art. High school art teacher Erin Ledyard has experienced "relevance as management" and states:

> *"It is also almost impossible, in the project/product-focused model of art teaching, to keep all students engaged all the time. The element of relevance is more important to a high school student than anything else in terms of the way they choose to behave in your classroom.*
>
> *Most of the time when a student is disengaged with the class they feel they cannot meet the expectations. Allowing them to meet the coursework at their own level is extremely helpful for this, especially for those students with special needs who are "mainstreamed" into your classroom." (38)*

SAMPLE BEHAVIOR FORM

Troubled students? A form such as the one below can help you keep track of behavior. It serves as evidence and allows you to register the disruptions. A form such as this can keep track of the "little" things – didn't bring homework, no pencil, late, left for a drink – sometimes these things add up to be problems, and sometimes they don't.

Name	Date	Time (Start - Finish)	Behavior	Adult Response
Shirley	04/06/11	2:02:15 - :45	Tapping pencil – making noises	Ignored
	"	02:05:20 (studio time)	Loud and gross burp	"
	"	02:07:00 (studio time)	Pinched Leslie	"Shirley, may I help you – or move you?"
Josh	04/06/11	6th hour	Didn't bring his homework.	

SAMPLE BEHAVIOR CONTRACT

Name: _____ Date: _____

What was the problem? (Where, when, why did it occur?)

My role in the problem was: _____

I should not have done the following: _____

I agree to make the following behavior changes: _____

I understand this class requires that I respect my classmates, the art room and myself. I understand my participation is important not only for myself, but for the other people in the room, too. I wish to continue in the class. I will work to help make it a pleasant place to be.

YES _____ NO _____

Signature of Student: _____

Signature of Teacher: _____

Teacher notes:

TIPS FOR STUDENT TEACHING

Understand that the philosophies and methods of your cooperating teacher might be different than yours. Do not judge the teacher or talk poorly about his/her ideas. Rather, if not learning content, learn what you can about organization, interactions, professional duties and school climate. Know someday soon, you will be free to teach, inspire and challenge students in your own way and style. Your student-teaching classroom is not your classroom.

That being said, when you are the student-teacher, you must **present yourself as the teacher** and act as if it is your classroom in front of the students. Students will sense any insecurity you might have about calling yourself a teacher.

Generally, traditional college students are not much older than high school students. **Do not worry about how old you look, rather, worry about how old you seem.** (Mantra to self: I am a leader. I am the defender of ALL the kids in the room. I expect much from myself and others.)

Always plan for more than you think you need. Beginners have a hard time organizing time. It is better to have back-up ideas rather than blocks of free time. Remember, unengaged students are problem students.

Be on time to everything. In fact, be early.

Do not call in sick unless you risk making other people sick.

Stay in contact with your university advisor.

Dress appropriately. I don't care if your cooperating teacher wears flip flops to school – I do not want to see you doing it. Be professional at all times.

Wear comfortable shoes.

Befriend the janitors and office staff. Make a good first impression. Shake hands, say hello and be approachable to everyone. (Practice shaking hands with your friends – your grip should be firm, dry and confident. Wimpy handshakes are a poor first impression.)

Attend all teacher meetings, even if you will be bored. Learn how the staff works as a team, and understand that you will be part of a team some day. :

Ask if you can sit in on other classes and watch other teachers teach, too. No matter what the subject matter is, all teachers offer valuable advice.

Remember to **be positive.**

Stay late when needed, come in early when necessary.

Take pictures of bulletin boards, yourself teaching, student art and student art shows for your portfolio.

Accept constructive criticism.

BRAVE ART & TEENS

Keep notebooks of content ideas to use in the future. Scan the books in the classroom for ideas. Ask your cooperating teacher if she/he will loan you some of his or her favorite books. (RETURN them!)

Eat with other teachers, but stay out of the lunch room drama.

Be confident. Or at least pretend.

Get to **know student names** as soon as possible.

Ask a lot of questions. College doesn't prepare you for everything.

Be willing to fail and succeed.

Try to secure a space of your own inside the class – a desk and working supplies. **Be prepared to buy your own supplies.**

Your student teaching experience will only be a slice of reality.

Be prepared with your own assignments, **ask how you can make them better** and ask if you can teach them.

Walk around the room, **get involved.** Never sit behind a desk.

Send thank you letters to your cooperating teacher and anyone else who helped and supported you in this journey.

Be sure to **act, not react,** when students misbehave.

Don't be shy about **writing down things.** Bring a notebook/pen along with you everywhere.

Wash your hands more often than usual. Buy (and use) Lysol.

CONTEMPORARY ART RESOURCES

Online and DVD: Art21

Books:

"Art on the Edge and Over," by Linda Weintraub

"The Power of Feminist Art," by Broude/Garrard

"Understanding Installation Art," by Mark Rosenthal

"Active Insights: Art as Social Interaction," by Van Loar and Diepeveen

"Mapping the Terrain: New Genre Public Art," edited by Suzanne Lacy

"Mixed Blessings," by Lucy Lippard (anything by Lucy!)

ACTIVIST ART. Museum Audience; Provokes Dialog; Social Commentary; Indoors. TOPICS FOR TEENS: How do you speak for yourself without speaking? What is your costume made of? What does your silence look like? What do you believe about others and how are you them? How do you form a common good?

Lorna Simpson. b. 1960. Early works address issues of body by pairing isolated details of the human figure or objects with fragments of text. Later works involve moving imagery about enigmatic conversations.

Zoe Leonard. b. 1961, NY. Early 1990s work dealt with person-becomes-object –

deals with issues of display.

Sue Coe. b. 1951. She is a "graphic witness" to factory farming, meat packing and other political events and social injustices. Printmaker – artist- activist.

Shirin Neshat. b. 1957, Iran. Iranian-born video and photography artist who has been living in NYC since '74 who looks at the complexity of how the Iranian woman melds with Islamic culture.

Kara Walker. b. 1969. Uses the 18th and 19th century art of silhouetting to attack American racial taboos in political, funny, beautiful and satirical ways.

INSTALLATION ART. Temporary, Indoors, Socially Engaged. TOPICS FOR TEENS: Where is your peace? What am I willing to notice in my world? Where is your quiet in the noise? How do you change what is wrong into what is possible? Who says you can't/won't/don't/shouldn't do? How do you feel censored? What consumes you? What are the things you carry?

Wolfgang Laib. b. 1950, Germany. Artist uses milk, stone, beeswax, rice and pollen as his main mediums. Installations strive to maintain awareness of organic and natural cyclical

processes.

Dread Scott. b. 1965. Dread addresses questions of public discourse from the standpoint of the oppressed by exposing the misery society causes for so many people.

Christian Boltanski. b. 1944. Gathered objects and articles based largely on autobiographical imagery as collective experiences. Often dealt with anti-Semitism and the Holocaust.

Barbara Kruger. b. 1958, New Jersey. Background as a graphic designer best known for her provocative black and white photographic images, banded with re stripes of text bearing bold messages, delivered in her trademark Futura Bold Italic. Raises questions about values, taste, materialism, war, abortion, racism, censorship, bigotry and power.

Faith Wilding. b. 1943, Paraguay. Faith was introduced to Judy Chicago in the early 70's and together they created the new "Women's Class" at Fresno State. She was involved in "Womanhouse" and worked with performance and installation art. Became affiliated with biotechnology and cyberfeminism movements.

Fred Wilson. b. 1954, Bronx. Wilson travels to museums across the country and reconfigures displays to make original interpretations to reveal hidden biases and ideologies.

Bill Viola. b. 1951. Multimedia video installation artist who orchestrates experiences between the physical, mental and psychological aspects of perception. Uses electronics to add sound, light and an overall environment.

PUBLIC ART. Outdoors, Sited, Socially-Engaged, Temporary. TOPICS FOR TEENS: What do you project? What is projected upon you? What does your faith look like? What place is a part of you? How are you a part of a place? What truisms are you from? How is your truth formed? Where do you look, stop and listen? Under what conditions do you thrive?

Krzysztof Wodiczko. b. 1943, Poland. Confronts contemporary society with its own tribulations. Pieces involve the projection of images onto public or commercial buildings as social critiques. The ephemeral projection last only a night or two and force the viewer to reexamine the function of architecture.

Francis Alys. b. 1959, Antwerp, Belgium. "When Faith Moves Mountains" brought 500 volunteers together to form a line to move a sand dune with a shovel.

Agnes Denes. b. 1938. Works for world hunger and the environment.

Devora Neumark. Canada. Non-profit community and activist arts advocacy and funding organization whose most recent initiatives are intended to stimulate dialogue about healthy interdependence and ethical responsiveness while encouraging artistic creation addressing the systemic causes of poverty. (from her website)

Peter Von Tiesenhausen. B. 1959, Canada. Eco-artist who allows his pieces to both absorb and be absorbed by the environment.

Jenny Holzer. b. 1950, Ohio. Text in public places, both permanent and impermanent.

Spencer Tunick. b. 1967. NY. Tunick temporarily installs hundreds of arranged nude human bodies at selected public locations for

photographic documentation.

Andy Goldsworthy. b. 1956. England. Collaborates with nature to produce artworks from natural materials—snow, ice, leaves, bark, rock, clay, stones, feathers petals, twigs to create sculpture. Before they disappear, or as they disappear, Goldsworthy, records his work in color photographs.

PUBLIC ART. Outdoor, Sited, Socially-Engaged, Permanent. TOPICS FOR TEENS: How do you overcome obstacles? What do you plant? How are you reflected in the past/present/future? What things small are seriously big to you? What is your unique link to the whole? What is the look of the bloom you bring to the world?

Richard Serra. b. 1939. San Francisco. Sculpts giant steel sculptures often specific to buildings/place.

Alan Sonfist. b. 1946. Sonfist is concerned with preservation and renewal of the environment by providing actual examples of the natural environment that existed prior to human intervention.

Maya Lin. b. 1959, Ohio. Maya designed the prize-winning Vietnam Veterans Memorial in D.C, 1982.

Tom Otterness. b. 1952. Kansas. Sculptor who casts his work in bronze, giving it the look and feel of monuments; however, by creating subjects which at first glance seem too cute to be serious, he undermines their sense of importance.

PERFORMANCE ART. Temporary, Body, Participation/Witness/Audience. TOPICS FOR TEENS: What do you do? What is your vocation in the world? How does recovery evidence itself in you? What are you connected to? Who do you perform for? If you had two wishes, which one comes first?

Mierle Laderman Ukeles. b. 1939, Denver. Artist-in-Residence for the New York City Department of Sanitation. Choreographed "ballets" performed by garbage trucks and construction, scrubbed sidewalks, created installations at landfill, shook hands with solid waste personnel.

James Luna. b. 1950, La Jolla Indian Reservation, CA. Luna is a counselor on alcoholism. He understands that part of the process of recovery is talking about problems. Promotes dialog and making his work accessible to community.

Adrian Piper. b. 1948, New York. Scholar, performance artist, works with ideas of Ideology, confrontation and political self awareness.

Karen Finley. b. 1956, Illinois. Part of the NEA FOUR. Performance artist reflects on

social injustices, personal reflection.

Linda Montano. b. 1942, NY. Performance artist words with ideas of deep meditation. Early piece tied herself to another artist for one year. Some performances last 12 years.

William Pope.L. b. 1955. Visual and performance/theater artist and educator who crawls across public venues often wearing a Superman uniform.

Janine Antoni. b. 1964, Freeport, Bahamas. Mediums have included sculptural forms made of chocolate, fat, soap, and weaving. Regards historical and contemporary ideas about representation ad gender.

Yoko Ono. b. 1933, Tokyo, Japan. Early Fluxus performer.

Marina Abromavic. b. 1946, Belgrade, Yugoslavia. Performance artist who explores the physical and mental limits of her being.

Chris Burden. b. 1946, Boston. Conceptual artist works with temporary installation.

COLLECTIVE/COLLABORATION. Research, De-Centered, Socially-Engaged. TOPICS FOR TEENS: Who/what do you collaborate with? What do you personally find a beautiful within the ordinary? How does art and knowledge intersect with you? How do you know you are home? Where is your faith? To what family do you really belong?

Judy Chicago. b. 1939. Constructed "The Dinner Party" – a massive ceremonial banquet in art that celebrates female artists/scholars.

Group Material. Public advocates about education, electoral politics, AIDS, cultural participation. Used community spaces for sharing information. Dissolved group.

Guerilla Girls. b. 1985. Feminist collective that consists of anonymous gorilla mask-wearing members whose identities remain anonymous. They plaster posters and billboards in pubic spaces to promote feminist issues.

Tim Rollins. b. 1955. Led to "Kids of Survival," or KOS who were special education/gang high school kids who worked together to make art often from the pages of literature (literally).

Peggy Diggs. b. 1946. A proclaimed "temporary interventionist." Utilizes murals, business cards, shirts, place mats, milk cartons, etc.

Susan Leibovitz Steinman. "River of Hopes & Dreams" with 75 high schoolers.

TEACHING PORTFOLIO

At the interview, greet the principal with a firm handshake, professional attire, and a teaching portfolio for his/her consideration. This portfolio will contain information the busy principal can scan to see what your ideas for the classroom are, what the quality of your artwork is, and other information to showcase your skills. The portfolio must be visual, easy to navigate, and stand out from other portfolios. Rarely will a principal keep it to examine, mostly they will scan through the book during the interview. The portfolio should include the following VISUAL items in tabbed parts:

1. Resume (on good paper).

2. A ONE-PAGE teaching statement formatted to match the resume. The statement is a short and concise summary about what the ideal classroom will look and feel like – what and how things will be taught. Grab attention, don't repeat ideas, and be sure the document is error free!

3. Transcripts.

4. Certifications.

5. Letters of references.

6. Awards and photographs of yourself teaching.

7. Artwork. Cropped, crisp. Label images with title, medium, date, size.

8. Lesson plans, worksheets, rubrics, print outs of PowerPoint presentations that go with them.

9. Notes or cards from students, parents or supervisors.

Other items might include:

Newspaper articles, website screen shots, etc., that show involvement in the arts.

The back of your portfolio can include other education papers, assignments, supplements that you may wish to include. The portfolio should feel cohesive, be clean, and exude professionalism.

RESUME

Things to include in a professional resume:

1. **Contact Information**
 - ✓ Full name (as it appears on transcripts)
 - ✓ Address
 - ✓ phone number
 - ✓ email (do not use hottie4u@hotmail.com ... be professional!)
 - ✓ website (if applicable AND professional)

2. **Education**
 - ✓ List most recent education first
 - ✓ Degree
 - ✓ School, city, state (write out the name of the school, do not put EWU)
 - ✓ Date of graduation. If still in school, state: Pending, May, 2019.
 - ✓ If GPA is 3.5 or above, mention it.
 - ✓ You can list awards and honors here, or if there are many of them from other venues, these will be mentioned in a separate heading.

3. **Related Experience**
 - ✓ List most recent experience first. This experience can be paid or unpaid, an internship or a substantial class project, volunteer positions, service learning, classroom placements, etc. Emphasize the skills used in these experiences that are most akin to the job you are seeking.

NOTE: If still in school, or still in a job - use present tense (I develop ...) . If the experience is in the past, use past tense (I developed ...)

- If no related experience, still list employment background. This shows an employer basic work ethics and skills such as taking responsibility, working cooperatively with co-workers, customer service, time management, or other characteristics that are important to any work environment. Think about skills that are transferable to a different work setting. List the following:
 - The job title, name and location (city and state) of organization
 - Dates of employment (month/year)
 - Concise description of accomplishments. Use phrases; not complete sentences.

Example:
9/2009 - 5/2011
Community Crisis Center Volunteer, *Midland Shelterhouse*, Spokane, WA.
— Formulated community resources for citizen needs.

— Made referrals for mental health and social services issues.
— Scheduled other volunteers for telephone hotline shifts.

4. Art Shows.

2012

<u>Small Works</u>. *Long Beach Island. Found. of Arts & Sciences*. Juror: Jeff Guido, Director, Clay Studio, Philadelphia.

<u>Works on Paper</u>. *Fort Worth Community Arts Center*, Fort Worth, TX. Juried group show.

<u>Saints, Goddesses, and Bodhisattvas</u>. *Marnie Scheridan Gallery*, Nashville, TN. National juried exhibition of figurative art.

5. Activities, Honors, Leadership (one, two or all words)

Accomplishments and extracurricular activities tell an employer about your interests, motivations, and skills (e.g. organizational, leadership, interpersonal, etc.). You may include scholarships, awards, recognition of academic achievement, etc.

6. Skills

Art skills, languages etc.
USE DYNAMIC VERBS:

Accrue	Chaired	Counsel	Expand	Investigate	Present
Acquire	Change	Critique	Expedite	Itemize	Prevent
Achieve	Chart	Cultivate	Explain	Join	Printed
Act	Check	Customize	Fabricate	Justify	Prioritize
Activate	Choose	Decide	Facilitate	Launch	Process
Adapt	Clarify	Declare	Finance	Learn	Produce
Address	Classify	Decline	Focus	Lecture	Program
Adjust	Coach	Decorate	Forecast	Led	Promote
Admin	Collaborate	Dedicate	Formulate	Lessen	Propose
Advertise	Collate	Define	Foster	Lift	Prospect
Advise	Collect	Delegate	Fund	Link	Prove
Advocate	Combine	Deliver	Furnish	Listen	Provide
Affirm	Communicat	Demonstrate	Gain	Maintain	Publicize
Aid	Compare	Depreciate	Generate	Manage	Purchase
Alert	Compile	Describe	Graduate	Manipulate	Pursue
Align	Complete	Design	Greet	Map	Qualify
Allocate	Comply	Determine	Guide	Market	Run
Analyze	Compose	Develop	Handle	Measure	Rate
Apply	Compute	Devise	Help	Mediate	Reach
Appraise	Conceptualiz	Diagnose	Hire	Merge	Receive
Approve	Conclude	Direct	Host	Mobilize	Recommend
Arbitrate	Condense	Dispatch	Identify	Modify	Reconcile
Arrange	Conduct	Dispense	Illustrate	Monitor	Record
Assemble	Confer	Distribute	Implement	Motivate	Recruit
Assess	Configure	Document	Improve	Negotiate	Reduce
Assign	Connect	Draft	Improvise	Observe	Refer
Assist	Conserve	Edit	Increase	Obtain	Refocus
Attain	Consolidate	Educate	Index	Open	Regulate
Authorize	Construct	Emphasize	Influence	Operate	Reorganize
Award	Consult	Encourage	Inform	Order	Repair
Begin	Contact	Enforce	Initiate	Organize	Replace
Brief	Continue	Engineer	Innovate	Originate	Report
Bring	Contribute	Enhance	Inspire	Outpace	Represent
Broadcast	Control	Ensure	Install	Outperform	Research
Budget	Convert	Establish	Institute	Participate	Reserve
Build	Convey	Estimate	Integrate	Perform	Resolve
Calculate	Convince	Evaluate	Interact	Persuade	Respond
Campaign	Coordinate	Examine	Interview	Plan	Restore
Certify	Correspond	Execute	Introduce	Prepare	Restructure

When taking photos of your artwork, use morning light, between 11 am and 2 pm on a sunny day – outdoors! Never use a flash. Be sure to photograph your work before you frame it or varnish over it (so the glossy surface won't reflect light). If making pictures of sculptures in the sunlight you might need a reflector, basically a white surface with which you can reflect the sunlight onto the shaded side of the sculpture to soften sharp shadows.

Do not lean a painting against a wall to photograph it, as it will distort. Hang it on a nail and position a tripod (or chair) directly in front of it. Do not aim the camera higher or lower than the piece, as that will distort the image. Aim the camera at the center of the painting.
→ Keeping the plane of the camera even to the plane of the artwork. ←

If it is a 3-D piece, find black, white or gray cloth to place the work on and/or in front of, so the table or wall does not compete with the art.

If the painting is small (circa 7" or less), you can get a decent photo from standing straight above the image placed on the floor – just be sure your shadow is not on the art when you make the photo.

Explore Digital Settings. Make the same photograph with different settings on the digital camera. Try macro shot, auto and manual. Remember, the COLOR needs to be as accurate as possible. If the digital camera allows for RAW images, choose that over JPEG as a JPEG compresses the image (and once saved in JPEG form, it can never retrieve that information).

After making the photographs, upload them to the computer using a photo editor such as Picassa or Photoshop.

These programs can crop the image and brighten/enhance the photos if needed. Crop so only the art shows in the photograph. Do not leave any information in the back of the painting (no paneling, wallpaper, grass, etc). The focus should be on the art only.

Presentation
The easiest way to show information about the art (title, size, date, medium) is to paste the art image into a Word document, and write the information in a text box without a border or background color. You can save this as a PDF file or Word .doc and print it on matte photo paper.

When including images of your art inside the portfolio, display the horizontal pieces and the vertical pieces in separate groups – that way the viewer doesn't have to keep flipping the book around.

Consider placement so that only one piece of art is on display at a time. For instance, first page is a plain black piece (perhaps with title/info on it) and the partner page is of the art (also displayed on a black piece of paper if it is not big enough to fill the page). Tape images to the base paper so they are not sliding around in the page protectors. Avoid glossy page protectors. Also avoid provocative art pieces – consider your audience and be professional at all times.

LESSON PLANS

TITLE: _____ TEACHER NAME: _____

AGE GROUP: _____ # OF DAYS: _____

GOAL: _____

STATE STANDARDS & OBJECTIVES:

MAIN VOCABULARY WORDS (With audience-specific definitions)

MATERIALS NEEDED (For both teacher and student)

Pre-KNOWLEDGE Expectations (or application)

INTRODUCTORY STATEMENT/EVENT. (What exactly are you going to do or say to grab student interests? Time:

ENTICER Activity. Time:

Research Sharing/MAIN LESSON. LESSON SEQUENCE: (What happens after the "grabber?" Include items such as teaching, PowerPoints, hands-on activities, list of questions to ask students, ***explanation of main assignment. Break down into increments/time slots. Be very specific about break downs. This may be a few pages long.) Time:

PRACTICE/brainstorming event. Time:

CHECKING FOR UNDERSTANDING. Time:

MAKE***ENCOUNTER QUESTION/Studio Experience:

DAY

If this is more than a one day assignment, briefly outline what will happen the following days.

REFLECTION

THE FIRST DAY

A first impression is not just a snap judgment about a person – but rather a tone for any interaction that is about to follow. The goal is to be perceived as someone with whom people will want to work. There is ample research that supports the notion that the first impression forms in the first seven to 17 seconds of meeting a person. Fifty-five percent of this impression is based on appearance, seven percent on the words, and 38 percent on the tone of voice. This configuration suggests that even before someone gets sufficient time to demonstrate their abilities, the first impression is already cast – and is hard to reverse. Some studies suggest it can take up to 22 positive subsequent interactions before a negative first impression begins to change. What impression do you want to portray? For me, I want to show this:

Welcome! I am glad you are here, and I look forward to working with you. This is our room, these are our tools, and we will respect them. This is a serious class, and we will learn and grow more than we can imagine—with the help of each other. My expectations of every person in this room (including myself) are high, and sub par performance is not acceptable. By choosing to come back tomorrow, you choose to participate in making such a vision happen.

<div align="center">I.</div>

Welcome! I am glad you here and I look forward to working with you. Students enter a room with chairs forming a circle. I sit with the students and introduce myself. Sitting with them, rather than standing over them, is more welcoming.

This is our room, these are OUR tools and we will respect them. I walk around the room and show them the sink, supply chest, computers, kiln, pencil sharpener, etc. and let them know that these supplies are "ours" and can be used as needed. I also stress that by taking care of the room, we show ownership, accept responsibility for our learning, and respect for the arts and ourselves. (In other words, we clean up after ourselves!)

<div align="center">II.</div>

This is a serious class, and we will learn and grow more than we can imagine—with the help of each other. Sitting back in the circle group, I ask each student to introduce themselves and why they are in the class—even what they feel about being here. I am aware that this causes great anxiety to most students, who are otherwise comfortable hiding in rows and not talking to a group, and I assure them that talking to the group will get easier as the semester ensues. However awkward the moment is, I have to set the stage for what is about to come and emphasize that dialogue is the core of this class. We also spend time trying to memorize names, since many of the students, no matter how small the school is, will not know everyone in the class. This often involves laughter—again

giving them da taste of what is to come. The adage, "Never let them see you smile" is ridiculous... I say, "Make sure they can pick out your laugh in a crowd."

<div align="center">III.</div>

I explain to students they will, at a minimum, receive at least one of three benefits from being in this class: a career path, an appreciation for the arts and/or a way to help cope/transform with life. I believe transformation is the best reason to be here. I explain that there are several stages of commitment to art:

- Early Childhood Experiences - when most people are uninhibited and joyful about making marks.
- Pre-Teen - when most people refuse to move forward with their art selves. Most adults in the USA are at this level of art ability.
- Adolescent Art – the people in this class.
- Adult Art – hobbyists
- Adult Art - Professionals

<div align="center">IV.</div>

I explain that adolescent art is not professional art. Rather, it is an exploration of choices, an extension of learning, an exposure to their hidden creativity. In other words, students in this class need not be "artists," and art class, under my direction, is helping teens transform into aware adults. Therefore, there is no room for brutal criticism. However, bravery is expected.

I go on to explain art skills are learned skills. Just like knowing how to dribble a basketball; speaking a second language; playing the guitar. Art is a skill that gets better with practice.

[Students really dig this part of the conversation – they feel a weight lifting from their shoulders, as so many people wrongly think that artists are "born" artistic.]

What is brave art? I cannot really describe what it will look like—it can be ugly, beautiful, big, small, 2-D or 3-D, ephemeral and/or even involve performance or sound. The only real explanation I have of brave art is that the <u>artist must be willing to embrace mistakes as part of the process and message to make honest work based on personal knowledge.</u> (This sentence is already written on the board, we now discuss what it means to them).

<div align="center">V.</div>

My expectations of every person in this room (including myself) are high, and sub par performance is not acceptable. I show this impression by showing up (on time) carefully groomed, having all my papers in perfect order, my name and any other information written on the board, and a clear written outline of what I am going to say. This includes a brief bio about who I am and why I am there so they grasp my dedication to education and my commitment to art (Yes, I am an artist!) (Yes, I love teaching!). I will rehearse this at home several times and even time myself to make sure I don't have "lingering" time at the

end—meaning I want the class to be fully engaged for the entire class period. This also sets the stage for what is to come.

I should also note how I stand in the entryway at the beginning of class time. This shows students that I am "present," accountable, and not about to hide from them. We also discuss the syllabus and classroom "rights."

I call the "rules" our "rights." I emphasize that I believe with all of my heart and soul that a good education is a right.

<div align="center">VI.</div>

By choosing to come back tomorrow, you choose to participate in making such a vision happen. After all is said and done, students will leave and think about what they experienced: circle group, shared dialogue, a diverse group, a professional teacher/artist as a leader and tantalizing art materials ... they will sense that this is a "seriously serious" class and decide if they want to move forward. Students sometimes feel they do not have a choice in this matter; this is an opportunity to reinforce the idea that they have ultimate control over their own education. A teacher cannot plant seeds in a desert. Those with no interest will move on.

With the previous steps, I have set the tone for the rest of the school year. However, before they entered the room, I also took good care to make the environment feel welcoming too.

Environment. The "look and feel" of the environment can help foster group relationships and contribute to the first impression. By environment, I do not mean "fancy" or "well-funded," especially since I know that most art rooms are neither of these.

I've had many classrooms, including some without sinks—which meant I had to carry a five-gallon bucket to class for clean water and provide an empty bucket for the dirty water. Sometimes my "office" was my car, when I had to drive to three different schools a day. I've also worked off the "art cart"– traveling to various classrooms to teach art. In one district, my high school art room was moved into four different buildings for four years in a row! The most interesting art room I taught in was an old garage a few blocks from the main school. Students had to walk through the snow and rain to get to the class. We told people that our classroom had its very own waterfall since the roof leaked so badly! But we loved our art room, because we made it "ours." Twice a year we hosted an "Art Garage BBQ" where students grilled hotdogs and invited friends and family to view their installed art pieces in our room. We hung decorative lights, played music, and otherwise enjoyed sharing our space with those we loved.

There are spiritual and physical characteristics of a space that, after being a part of them in some way, becomes a place. This place isn't necessarily defined by borders or materials but rather by a lived location. In other words, the classroom place isn't about being Room 29, a garage, or an empty cinderblock square—but about the experiences and connections that happen inside. Communal space has a long history and comes in both concrete and

metaphysical forms. For instance, the Chinese art of feng shui, "wind water," is a sort of environmental psychology that has been a part of the Chinese culture for thousands of years and incorporates indoor living spaces with water, sunshine, and air flow. It is based on the notion that lives are deeply affected by our physical and emotional environs.

Allow students free reign to decorate "their" room. This inevitably leads to a feeling of ownership and respect and responsibility toward each other, the supplies, and the environment. It gives them control in subtle yet significant ways while the physical characteristics of the classroom contribute to the groups' identity.

Beware of simple things like traditional desks and tables becoming barriers and dictators. Desks can be leaned on, drawn on, and even slept on while separating and defining the space between people. A desk tells people where to sit and dictates how big or small art materials need to be. The group does not need to conform to prearranged desks. If tables and chairs are moveable in the classroom, allow the students to move them at will. Consider suggesting that students sit on the floor to work, stand against a wall, or even bring in their own pillows to class (tile/cement floors are cold.)

TECHNIQUE

Given the times, "art class" should no longer revolve around technique-based studio arts. However, it might be true that, without the ability to represent things convincingly, students may continue to feel inadequate in the arts. Teaching observational drawing is not fostering creative expression, but it can help build confidence.

So how does one bridge the contemporary world with traditional skills?

On the first day of my high school Art I courses, sitting in a circle, I ask each student to tell the group why they are taking an art class and what they hope to learn from it. Most students will report that they hope to learn how to draw in the class. At this point in their education, "drawing well" is the breadth of their knowledge about "art class" and that is okay ... they will learn! In response to such statements, I state with conviction that I can truly teach them to draw (and do other things). I declare this with vigor because I know the kids surrounding me are doubtful and it is my job, as the leader, to have passion and belief in my mission. Surely, after so many years of teaching, I believe I can teach anyone to draw. However, it takes a little more coaxing than that to settle the nerves in the room.

I tell these nervous teens that most people in the room – no matter if they are 15 or 50 – will draw at the level of an 11 year old and that such a skill set is NORMAL! I ask them to think about why this might be the case, and they understand that they haven't been asked to "create" anything since 5th grade! (It begins to make sense to them). Students will typically lighten up at this point.

I congratulate them on being brave enough to enter into a class that they felt inadequate to enroll in and I thank them for trusting me as their teacher. I tell these new art students that the room is full of many people who have different abilities. It is important that they do not judge their own work against other student work. They only need to work on improving their own work. I ask students who have more skills to help other students, to be patient and supportive of others (the "fearful"); yet remain open to ideas (the "egos"). Furthermore, for all students, I emphasize that **mastery of the lessons comes from their willingness to practice and that it is my hope that mastery via practice will eventually lead them to freedom from technique,** and that our sketchbook assignments will help us with this.

After more first day discussions, I pass out paper and have students make three "before" drawings: one of a hand, a one-point perspective of a room, and one of a simple object that I've placed on the desks (apple, pencil, wine bottle, etc). I provide about 10 minutes for each of these drawings and stress how important it is to do their best. I let them know these little drawings will be used as a gage to measure how much they've learned in class, as it will be hard to remember after a term goes by. I let them know that if they do not finish the drawing, that it will not impact their grade and reinforce that this is not about how "good" they are. I also tell them that I will be walking around the room to answer any questions they may have, but I will not comment about the work. I do this to eliminate the feeling of being judged and to circumvent the weirdness of my silence when students want to hear "good job" as I pass by. *[Teacher note: it is wise for a new art teacher to watch students draw these drawings. From my experience, I will bet 98% of the students charged with drawing their hand, for example, will NOT look at their hand – but draw*

what they think their hand looks like].

When the drawings are complete, I ask them to sign, date, and write a little note about what they are feeling at the moment on the back of the page. I collect these drawings, read their notes, and then give them back at the end of the semester. I do this because it is easy to forget how much they've learned. The day I give these "before" drawings back is one of my favorite days of the year.

After a few days of getting to know each other in an Art One class, we will begin our journey down "technique-row." Admittedly, these weeks are fairly dogmatic in approach as information needs to be "laddered" accordingly. This means that information is built upon information – old stuff is reinforced and new stuff is practiced. Generally I take the following approach: blind-contour ->contour -> shading -> texture -> overlapping -> composition ->charcoal -> perspective, etc.

A step might take 15 minutes or an entire class, but none of these topics requires days of investigation. For instance, I've seen assignments where students are forced to make a value scale so big that it took a week to make. Talk about dull. Students "get" what a value scale is merely by pressing hard and pressing soft with a pencil and talking about it in conversations about art.

There are many great books already published on teaching observational drawing skills and I suggest any beginning teacher spend the time to find them and formulate his/her own ladder of information and understand the "why" behind the exercises one assigns. This book, "Brave Art & Teens," is not about that, but I can direct you towards Dr. Betty Edwards' book titled "Drawing on the Right Side of the Brain" which provides wonderful insights into how to activate the creative/observational side of the brain

Introducing Concept. There is no reason "technique" can not be "relevant" too. After the first few weeks of drawing exercises pass by, and confidence is rising, I begin to wade my Art One class into the land of "concept." By this, I mean we begin to think about personal associations to art making through symbols and metaphor. For instance, if we want to reinforce the idea of composition, drawing, overlapping, shadow, texture, and value the teacher might want to assign a still-life experience. However, instead of merely drawing a still-life with a bunch of junky objects strewn about a table, I might ask students to bring in an object that best represents them (symbol). Students are then asked to place the objects according to how they fit within the group – a sort of class portrait (metaphor). Students then work together to make the display – still thinking about textures and composition – but also their own tangible contribution/placement to the class.

To the still life experience, I might add some imagery by Audrey Flack, explain the Latino idea of vanitas, or even contemporary "altar" works as examples of symbols in art. Such an assignment is an "easy" emotional stretch. It is not asking students to reveal too much, yet it helps them ease into the more profound experiences promised to come later in the semester. At this point in their art education, their focus is still on forming group and practicing their skills so they can confidently (and safely) go deeper and deeper into art's offering ... if they choose to take the next class.

REFLECTION FORMATS

Here are some format ideas. Importantly, these formats can be used in-process too, not just at the end of a studio experience. The ideas below can be/should be altered to fit the situation:

LARGE GROUP FORMATS

- Sit in a large group circle and have each student hold up his/her work and tell the class about it. Sometimes it is appropriate to:
- Ask them to begin the dialogue by answering a specific question. For example, tell the class how either: "I am like this art," or how "This art is most like me."
- Ask them to begin the dialogue by asking the class to offer up three suggestions for a title to the work presented.
- Ask the class to describe what they see, or how the piece makes them feel, before the artist reveals his/her ideas.
- Allow students to write down his/her thoughts about the art before sharing. Have students write their names on a sheet of paper and then have a student pick a paper from a pile to decide which piece gets attention next.
- Have students write a "title" on a piece of paper, put in a group pile. Someone selects and reads the title – which piece do they think represents that title? Why?
- Ask the class which piece they want to talk about first, and that person then selects who to talk about next.
- Ask the group what the objective of the studio experience was—and which piece/s does the group think most immediately addresses the objective. How/why?
- Ask the artist what they want to learn from the class before the reflection begins.
- Ask for at least four responses to the student's presentation before moving on. (Remember to wait silently until that happens!)
- Have students display their work all around the room, and then have them place a notebook next to their piece.
- Ask students to move from piece to piece and write down their descriptions/feedback of each piece. The teen artist will then have a nice collection of notes to keep/cherish at the end of the class.
- Consider "performing" the piece. Have students make up stories, assign characters, narrate, scribe dialog and even dress the part to share either a 3-D description, or an inspired story that the art provoked.
- What do you imagine the feelings and meanings this artwork represents?
- What titles could you give this artwork?
- What other things interest you about this artwork?
- In talking about your own work of art, what would you have done if you had had more time?

- Would someone be willing to talk about your own work?
- Practice honing some deconstructive propositions for feedback, such as, "My perspective may not be accurate, but this is what I see _____," or "What can we learn from each other?"
- Always be prepared with questions to fill any void that seems to be null of silent contemplation.
- Have all students display work and allow the class to discuss the work. To prompt discussion, sometimes it is appropriate to fill out a critique response form before beginning dialogue to help students dissect the work. Sample items might be:

The first thing I see is _____.
The most original part of the image is _____.
The work makes me feel _____.

- Provide students with a sentence that corresponds with the art experience. Write the sentence on the board and have them fill in the blanks, for example: "I am (noun) _____, (three adjectives) _____, _____, and _____." After writing their answer, turn off the lights and have students read their sentences. Do not go in a row, or organized circle—just tell students to read their sentence when they feel it is right. The projected sounds that come from unexpected areas in the room provide a nice rhythm.

SMALL GROUP FORMATS

- Divide the class up into two, three or four small groups and allow students To have longer and more intimate discussions about the work. Sometimes it is appropriate to ask them to:

 a. Poetically/creatively write down their thoughts about their work on a piece of unsigned paper. After students are finished writing, ask them to fold the paper and put it in a pile in the middle of the group.

 b. After mixing up the pile, have a student select a paper, read it, and allow for "sink in" time before moving on to the next student/piece of paper. Encourage discussion as necessary.

* Sometimes it is fun to begin the letter as "*Dear Artist, while considering your art, I learned _____.*" *Students will give thoughts to the artist when done.*

* Have the artists individually ask at least three people for feedback about their work. Then have students reconvene as a group to discuss what they learned and flush it out with the class.

As a group of students has learned the process, they are encouraged to conduct critiques on their own in small groups without direct teacher supervision. This type of teacher-free learning is my goal in art education. The more I can get students to ask questions and

develop answers for themselves, the more I can expect them to be life-long learners who will continue to develop their creative Selves and transformative processes without me. I encourage them to think like team members in the same way that athletes, actors, or business people work in teams. Their goal is help each other so that everyone can benefit from the practice. That means not hoarding the ball, but being sure that each person on the team is encouraged to express his or her ideas – in his or her own ways.

BIBLIOGRAPHY

1. Gude, Olivia. "Principles of Possibility: Considerations for a 21st-Century Art & Culture Curriculum." Art Education. 60 no1. January, 2007.

2. Lowenfeld, Viktor and Britton, W. Lambert. Creative Mind and Mental Growth. New Jersey: Prentice Hall. 1987 ed. Pg. 382.

3. Hetland, Lois, Winner, E., Veenema, S., Sheridan, K. Studio Thinking2: The Real Benefits of Visual Arts Education. Teachers College Press. 2013. Pg. 7.

4. Pink, Daniel. A Whole New Mind: Why Right Brainers will Rule the Future. Riverhead Books, NY. 2006. Pg. 2.

5. Bell, Liz. Correspondence with author. May, 2010. Liz was an advanced high school art student of mine at Hemlock High School, Hemlock, MI.

6. Malchiodi, Cathy. The Art Therapy Sourcebook. McGraw-Hill. 2009. Pgs. 12 – 15.

7. Brittain, W. Lambert, Ed. Victor Lowenfeld Speaks on Art and Creativity. Weston, Virginia: National Art Education Association. 1985 Re-Print. Pg. 54.

8. Masi, Daniel. In correspondence with author. July, 2010. Daniel was an undergraduate art education student of mine at Shepherd University and currently teaches and makes art.

9. http://www.Shishindo.org/leadership.html 3.9.3004.

10. http://www.infed.org/thinkers/senge.htm 8.10.10

11. Masi, Daniel.

12. Crossett, Kara. Correspondence with author. August, 2010. Kara's note to me included the sentence "It is hard to be brave in high school, I know!" and was the inspiration for the title of this book. Kara was my high school art student and student aide. Thanks Kara!

13. Lowenfeld, Viktor and Britton, W. Lambert. Creative Mind and Mental Growth. New Jersey: Prentice Hall. 1987 ed. Pg. unknown.

14. London, Peter.

15. Wheatley, Margaret. Turning to One Another: Simple Conversations to Restore Hope for the Future. Berrett-Koehler Publishers; Second Edition (February 1, 2009). Pg. 25.

16. I learned this trick while attending one of his workshops. Check out Peter London's website to attend one for yourself: www.peterlondon.us

17. Smith, K. Jeffery and Lisa F. Smith. International Association of Empirical Aesthetics. Spending Time on Art. 2001, 19:2, 229-236.

18. Dissanayake, Ellen. Homo Aestheticus: Where Art Comes From and Why. The Free Press, 1995. 39-63. Pg. 47.

19. London, Peter. Correspondence with author, excerpt from pre-published working paper titled, "Joining Heaven and Earth."

20. Feldman, Shoshana. Education and Crisis, Or the Vicissitudes of Teaching. American Imago, Vol 48(1), 1991. Pgs. 13-73.

21. Scott, Dread. Correspondence with author. 4.6.2003.

22. Perry, William G., Jr. (1981). Cognitive and Ethical Growth: The Making of Meaning, in Arthur W. Chickering and Associates, The Modern American College (San Francisco: Jossey-Bass): 76-116.

23. Rogers, Carl. Transcribed lecture. Significant Learning: In Therapy and in Education, Goddard College, Plainfield, VT. February 7, 8 and 9, 1958.

24. Gardner, Howard. Frames of Mind: The Theory of Multiple Intelligences. 1993. Pg. xix.

25. "What is Emotional Intelligence?" http://helpguide.org/mental/eq5_raising_emotional_intelligence.htm 1.13.11

26. Dewey, John. Art as Experience. New York: Perigee Books. 1934. Pg. 35.

27. Perkins, Dr. Emma Gillespie. CVC Instruction: Revisioning Creativity. NAEA Boston presenter. 3/2005.

28. Bartel, Marvin, "Image Flooding," http://www.goshen.edu/~marvinpb/arted/tc.html#html 3/20/2003

29. London, Peter. Pgs. 14 – 17.

30. Bartel, Marvin. "Creativity Killers," http://www.goshen.edu/art/ed/creativitykillers.html 8/10/10.

31. Brain Scientists Identify Close Links between Arts, Learning" http://www.dana.org/news/artseducationinthenews/detail.aspx?id=21838 1.13.11.

32. Dewey, John. Pg. 46.

33. Taylor, Pam. Pg. 14 – 19.

34. Segments came from Tim O'Brien's text, The Things They Carried, Broadway Books. Re-print. 1998.

35. London, Peter. Pgs. 100 – 103.

36. Goza, Amanda. Correspondence with author. 8. 2011.

37. London, Peter. Pg. 66.

38. Ledyard, Erin. Correspondence with author. July, 2010. Erin is a high school teacher, and a former student-teacher of mine.

Jodi A. Patterson has more than two decades of teaching experience in public schools and universities. "Brave Art & Teens" was written while she was living atop the Irish Sea in a quaint town outside of Dublin.

www.jodipatterson.net

NOTES

BRAVE ART & TEENS

BRAVE ART & TEENS

Made in the USA
San Bernardino, CA
25 May 2016